First published in the United States of America in 2014 by
Rockport Publishers, a member of
Quayside Publishing Group
100 Cummings Center
Suite 406-L
Beverly, Massachusetts 01915-6101
Telephone: (978) 282-9590
Fax: (978) 283-2742
www.rockpub.com
Visit RockPaperInk.com to share your opinions, creations, and passion for design.

10 9 8 7 6 5 4 3 2 1

ISBN: 978-1-59253-932-1

First published in Asia in 2012 by
Page One Publishing Pte Ltd
20 Kaki Bukit View
Kaki Bukit Techpark II
Singapore 415956
Tel: [65] 6742 2088
Fax: [65] 6744 2088
enquiries@pageonegroup.com
www.pageonegroup.com

First published 2012 by Page One Publishing Pte Ltd

Editor: Joy Cheung, Lee Min Kok
Designer: Wiwi Evelyn

SKETCHING BASICS: ONE POINT PERSPECTIVE

Author
Ruzaimi Mat Rani
Co-Author
Dr. Rashidi Othman
Aidaliza Aga Mohd Jaladin

Illustrator
Ruzaimi Mat Rani

PREFACE

The renowned English writer Samuel Johnson once remarked, "Great works are performed, not by strength, but by perseverance". This is a good phrase to ponder. An artist needs to master the basic skills and grasp a fundamental knowledge in sketching before embarking on more complex sketching skills.

This book is written for anybody with an interest in basic sketching. It is relevant to many areas in the wide field of the arts and design, including architecture, interior design, applied arts, graphic design, and multimedia. It is also suitable for understanding the basic methods of sketching.

In this book, the foundational methods of sketching are succinctly and clearly explained. These methods have long existed, but have never been thoroughly explained. Any artist or designer will be able to easily comprehend the step-by-step illustrations in this book.

Ruzaimi Mat Rani

SKETCHING BASICS

ONE POINT PERSPECTIVE

Rockport Publishers
100 Cummings Center, Suite 406L
Beverly, MA 01915

rockpub.com • rockpaperink.com

CONTENTS

Chapter 04 : Creative Compositions in One Point Perspective

ACKNOWLEDGEMENT

To be able to realise my dream of publishing this book and to share my knowledge with my readers are the greatest joys that I have experienced in my life. My deepest gratitude goes to all my teachers and lecturers, without whom I would not have been able to gain as much sketching knowledge and skills as I possess today. My earnest appreciation goes to my co-author and publisher who assisted me in completing the book. Of course, this book would not have been possible without the support and strength of my family: Aidaliza, my beloved wife who has been with me through thick and thin in supporting me to complete this book; my adorable children, Athirah and Hazim; my beloved parents, Haji Mat Rani and Hajjah Maznah; my dear parents in-law, Haji Aga Mohd Jaladin and Hajjah Mahyah; the rest of the family members and my friends.

Good News

I have published a blog at freedrawinglesson.blogspot.com to share my humble knowledge on how to sketch using stop motion demonstration videos (demo videos). I hope to produce more than 1000 demo videos to share with people around the world

CHAPTER ONE
Basic Sketching: One Point Perspective

1.1 INTRODUCTION

Basic sketching techniques and a fundamental knowledge of what constitutes a one point perspective are the two most important factors for an artist or a designer to master good sketching skills. Basic sketching skills comprise handling sketching equipment, manipulating media, drawing lines and rendering. Meanwhile, a fundamental knowledge of a one point perspective entails understanding its components and settings.

Basic sketching skills can be acquired from reference materials such as books, or attending relevant art or graphic workshops. These sources are important providing you with a good foundation for basic sketching techniques. The saying "Practice makes perfect" may be cliched, but it is true. Hence, artists and designers should constantly practice their sketching skills in order to hone them. This is a necessary process for anyone who wants to master sketching.

Without a good grasp of the components and settings of a one point perspective, it is impossible to produce a one point perspective composition of substantial quality. It will take some time to understand the concept of a one point perspective. Do observe the examples given in the following chapters in order to have a clear understanding of a point perspective sketching.

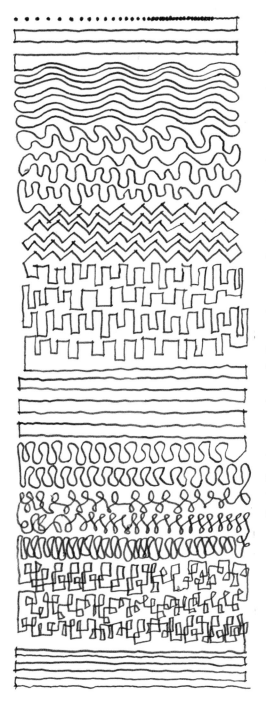

1.2 A POINT TO LINES

From a point, many types of lines can be created or sketched. There are straight, curvy, and zigzagged lines, just to name a few. A proper technique is needed to sketch lines well. You should start with a simple, straight line, then go on to more complex line compositions.

You should begin with sketching media which ranges from line media to colour media. Common line media are pen and pencil. Color media consists of color pencils, art markers, pastels and many more. The next step is to choose your paper carefully from numerous types of papers. The paper you select must suit the type of medium you use.

Creativity is needed when sketching lines. Composing any line composition, simple or complex, requires skills, practice and observation. There are many types of lines available by observing natural as well as man-made environments. Imagine the lines and sketch them nicely on paper. Then proceed to more difficult line compositions.

There is no short cut in mastering good sketching skills. 'Practice makes perfect' is a good mantra to follow. Besides that, self-confidence is also needed to sketch well-formed lines.

1.3 A LINE TO TWO DIMENSIONAL COMPOSITIONS

Composing two dimensional compositions is the next sketching process that you can explore. Lines can do wonders in creating these two dimensional compositions. Start with a simple composition, using basic shapes for example, then continue with complex two dimensional shapes. You should then proceed to objects composition. Do observe the two dimensional composition given. Certain compositions require more than one type of line to be sketched.

1.4 A LINE TO THREE DIMENSIONAL COMPOSITIONS

Next, you can look into creating three dimensional (3D) compositions. This sketching process requires a strong imagination and good sketching technique in handling the compositions because these compositions require volume estimation. 3D compositions require the artist or designer to maneuver lines on a sketch surface. These lines must be placed in exact locations on the sketch surface. This ability is necessary in sketching objects well.

1.5 LINES & PATTERNS

Patterns are important in sketching. They are used to show a composition's textures and details. As shown here, many patterns can be created using lines.

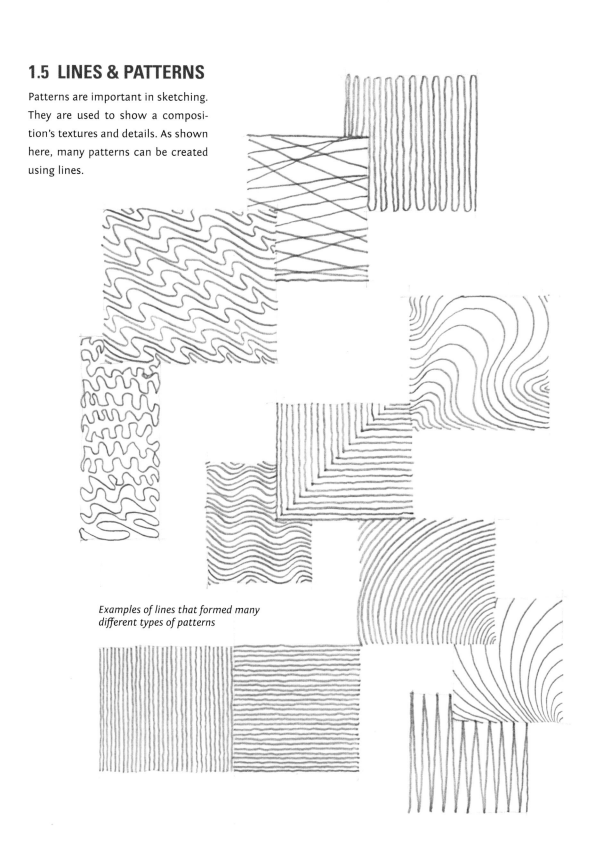

Examples of lines that formed many different types of patterns

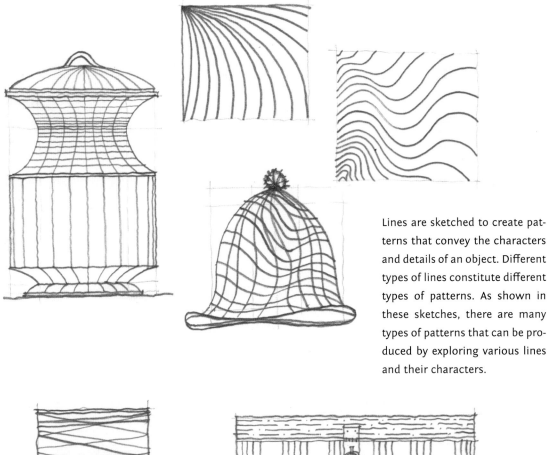

Lines are sketched to create patterns that convey the characters and details of an object. Different types of lines constitute different types of patterns. As shown in these sketches, there are many types of patterns that can be produced by exploring various lines and their characters.

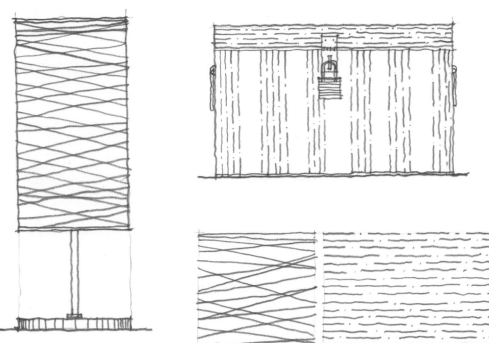

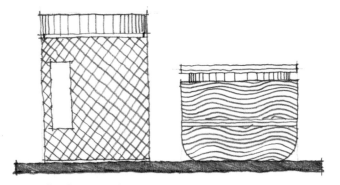

Examples of lines that formed patterns for the objects' surfaces

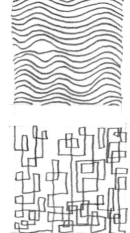

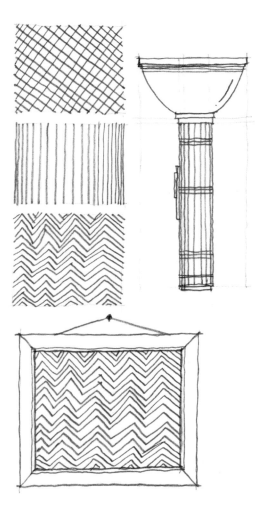

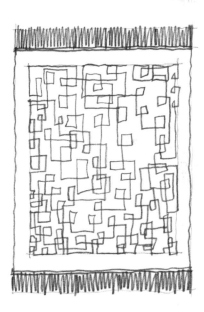

These sketched objects demonstrate that many different types of lines can be introduced to a sketched object to form its patterns. For example, the torchlight is sketched using two types of lines: horizontal and vertical. Each of them creates different types of patterns to give character and identity to the torchlight.

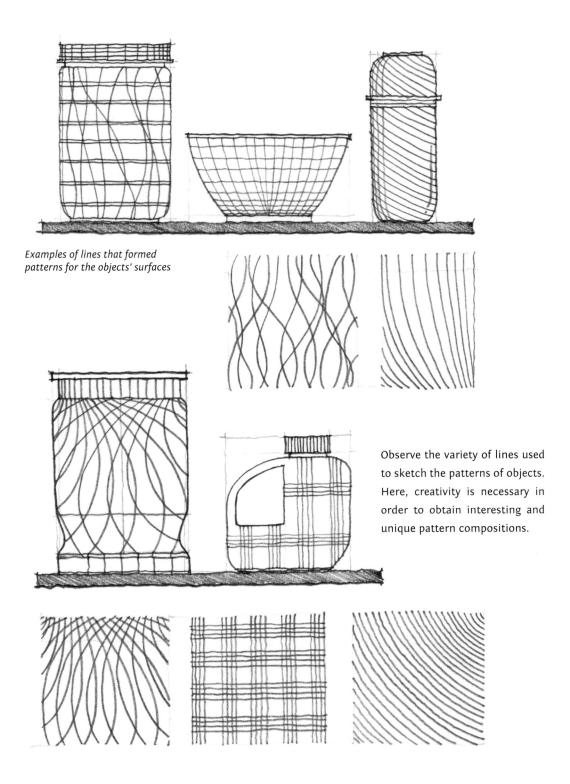

Examples of lines that formed patterns for the objects' surfaces

Observe the variety of lines used to sketch the patterns of objects. Here, creativity is necessary in order to obtain interesting and unique pattern compositions.

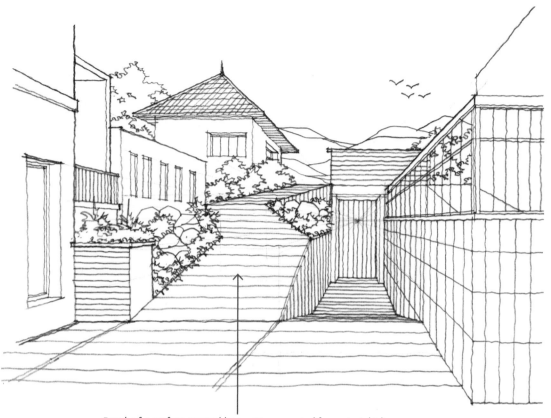

Depth of a surface created by a pattern created from straight lines.

As shown here, patterns are also employed in 3D sketches to give characters and identity to the compositions. Patterns are also used to provide depth to the surfaces of a space.

1.6 ONE POINT PERSPECTIVE

It is good to have a basic knowledge on perspective setting, which can be used as a guide in sketching. The one point perspective is a perspective setting that uses only a vanishing point, located at the horizon line, as its reference.

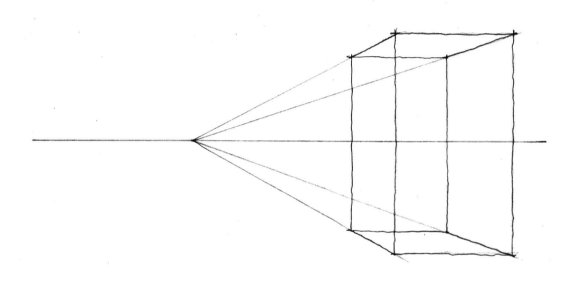

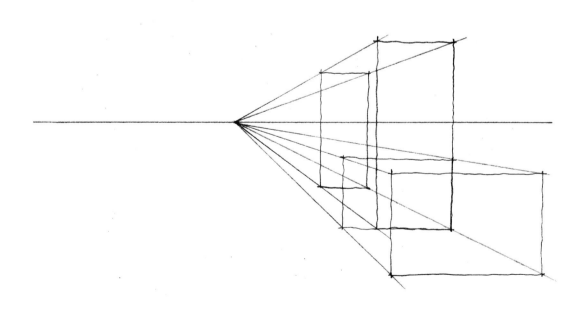

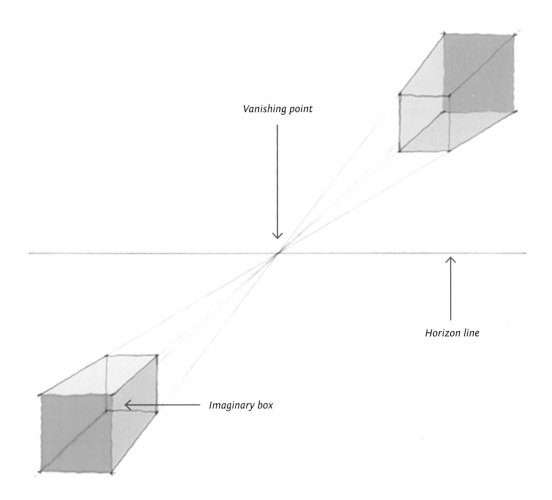

Vanishing point

Horizon line

Imaginary box

1.7 ONE POINT PERSPECTIVE COMPONENTS

One point perspective components are a vanishing point, a horizon line (eye level) and an imaginary box. The vanishing point can be located anywhere along the horizon line. The vanishing point controls the viewing direction towards the horizon line. The horizon line determines the eye level of the view.

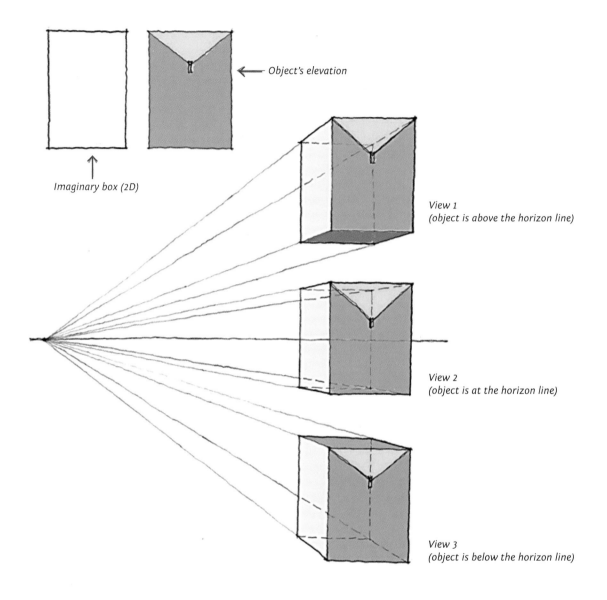

Object's elevation

Imaginary box (2D)

View 1
(object is above the horizon line)

View 2
(object is at the horizon line)

View 3
(object is below the horizon line)

1.8 PERSPECTIVE VIEWS

It is important to understand the origin of a line because a line contributes to the formation of any sketch composition. Observe any sketch created. You will find that each line used in a composition has its own meanings and functions.

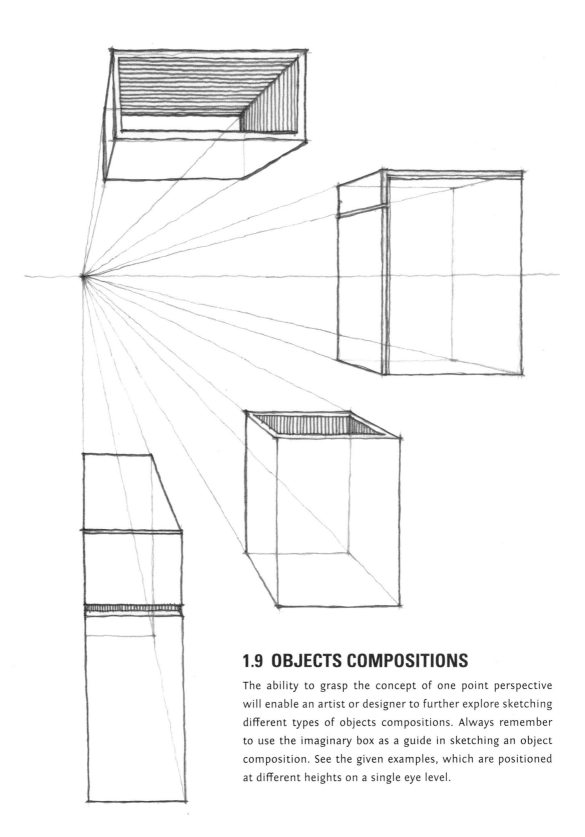

1.9 OBJECTS COMPOSITIONS

The ability to grasp the concept of one point perspective will enable an artist or designer to further explore sketching different types of objects compositions. Always remember to use the imaginary box as a guide in sketching an object composition. See the given examples, which are positioned at different heights on a single eye level.

CHAPTER TWO

Imaginary Box In One Point Perspective

2.1 INTRODUCTION

The imaginary box is an interesting compo-
nent in a perspective setting. It is used as
a reference or guide to compose an object.
The imaginary box concept can be applied
to 2D and 3D objects. It is good to begin
employing the imaginary box in 2D sketch-
es before proceeding to 3D compositions.

Using the imaginary box concept in
sketching can produce wonders for artists
and designers. During sketching, the im-
aginary box functions as a reference and
boundary to a composition. It also helps
to define a good scale and proportion in a
composition.

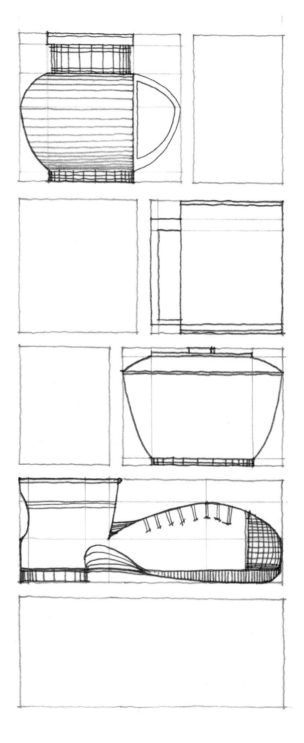

2.2 IMAGINARY BOX IN TWO DIMENSIONAL SKETCHES

There are many interesting compositions that can be sketched using the imaginary box. It is good to start using the imaginary box in a simple object composition, such as a cup or a cupboard, before proceeding to more complex compositions, like a table, a chair, or a lamp post. Do practice sketching any object composition using the imaginary box based on your imagination. Try not to refer to sources such as books, magazines, or even real life compositions.

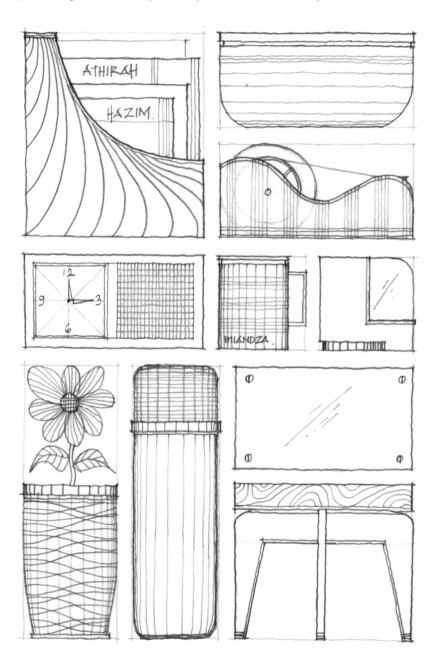

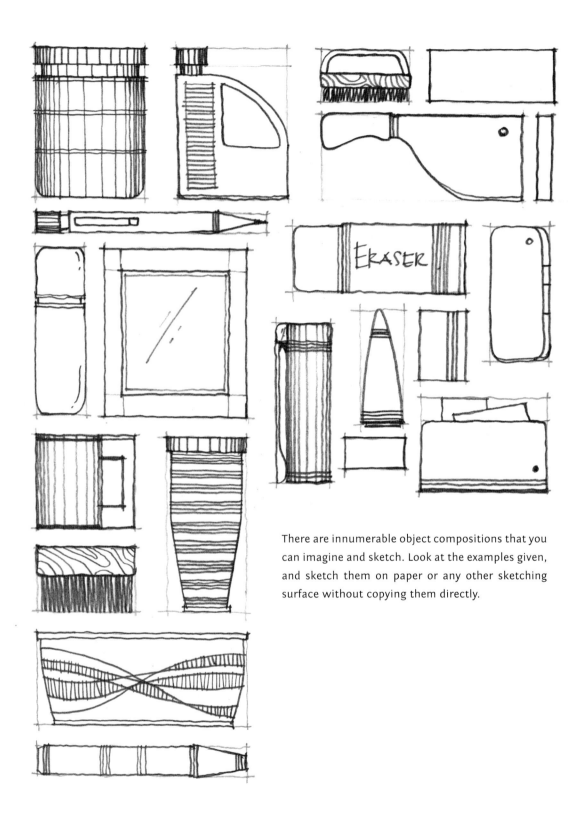

There are innumerable object compositions that you can imagine and sketch. Look at the examples given, and sketch them on paper or any other sketching surface without copying them directly.

2.3 IMAGINARY BOX IN ONE POINT PERSPECTIVE

The imaginary box is a very important component in one point perspective setting. Before you begin to use the imaginary box, you must have a fundamental knowledge of one point perspective setting. The creation of the box should always refer to the principle of one point perspective setting. The imaginary box can only be created using squares and rectangles.

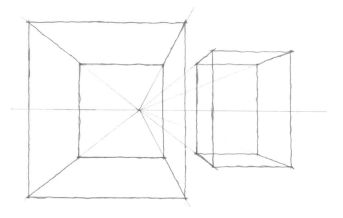

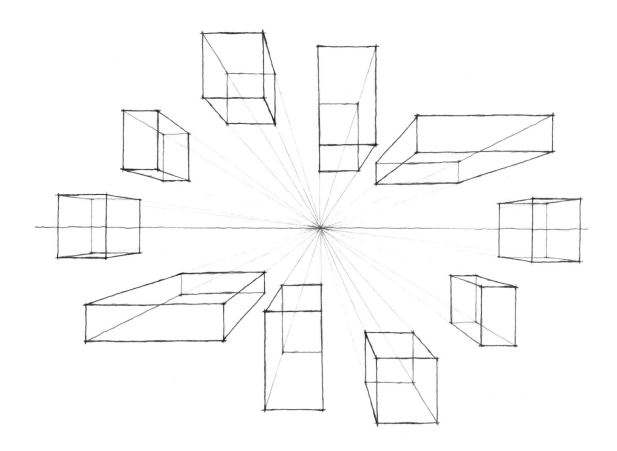

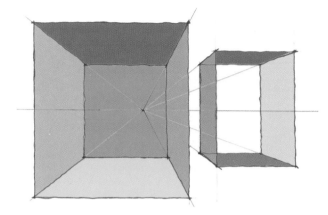

It is also important to grasp the character of the imaginary box in a one point perspective setting. The character of the imaginary box mentioned is related to the changes of its surfaces towards the changes of height and its positions. Do observe the examples given where the horizon line (eye level) is fixed to a position while the imaginary boxes change based on their heights and positions.

Examples of imaginary boxes

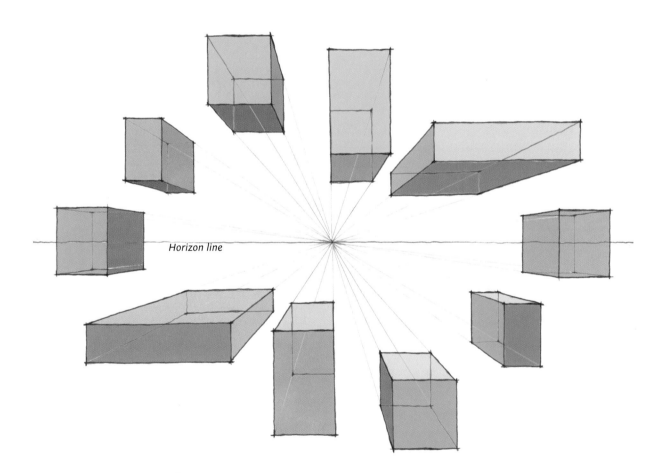

Horizon line

Multiple positions of imaginary boxes based on a vanishing point and horizon line.

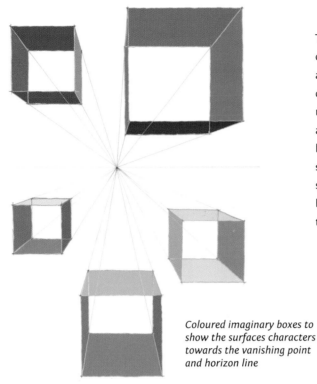

The imaginary boxes are coloured to show clearly the surface characters of each imaginary box. The characters change according to their locations and positions in relation to the horizon line. Look carefully at the imaginary boxes located above the horizon line. Their bottom surfaces can be seen clearly. On the other hand, the top surfaces of the imaginary boxes located below the horizon line appear clearer than their bottom surfaces.

Coloured imaginary boxes to show the surfaces characters towards the vanishing point and horizon line

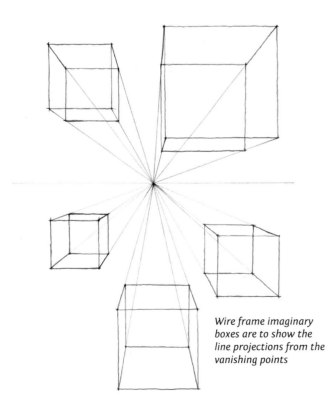

For the side surfaces, their appearance strongly depends on their positions in relation to the vanishing point. Look carefully at those surfaces. When the surfaces are located either on the left or right of the vanishing point, these surfaces can be seen clearly. As demonstrated in the examples given, the side surfaces appear clearer the further their location from the vanishing point.

Wire frame imaginary boxes are to show the line projections from the vanishing points

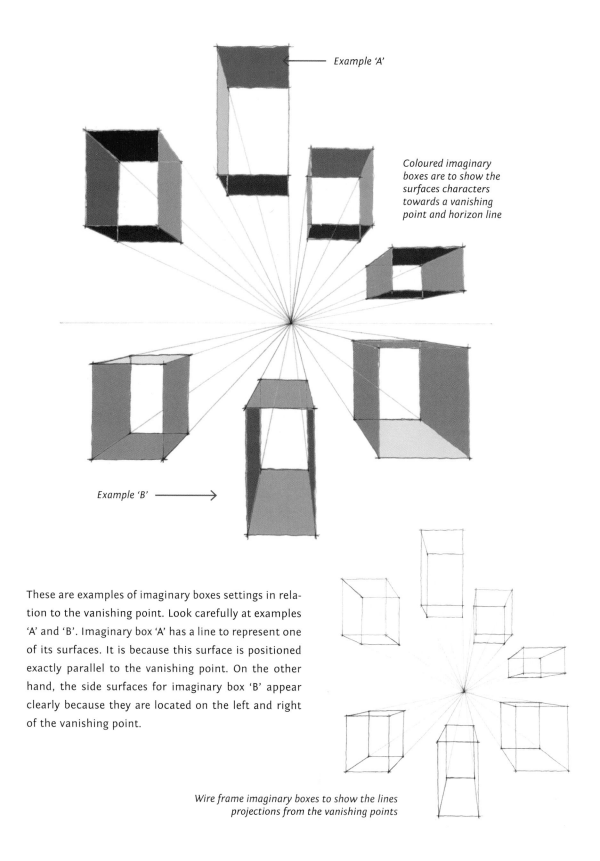

Example 'A'

Coloured imaginary boxes are to show the surfaces characters towards a vanishing point and horizon line

Example 'B' →

These are examples of imaginary boxes settings in relation to the vanishing point. Look carefully at examples 'A' and 'B'. Imaginary box 'A' has a line to represent one of its surfaces. It is because this surface is positioned exactly parallel to the vanishing point. On the other hand, the side surfaces for imaginary box 'B' appear clearly because they are located on the left and right of the vanishing point.

Wire frame imaginary boxes to show the lines projections from the vanishing points

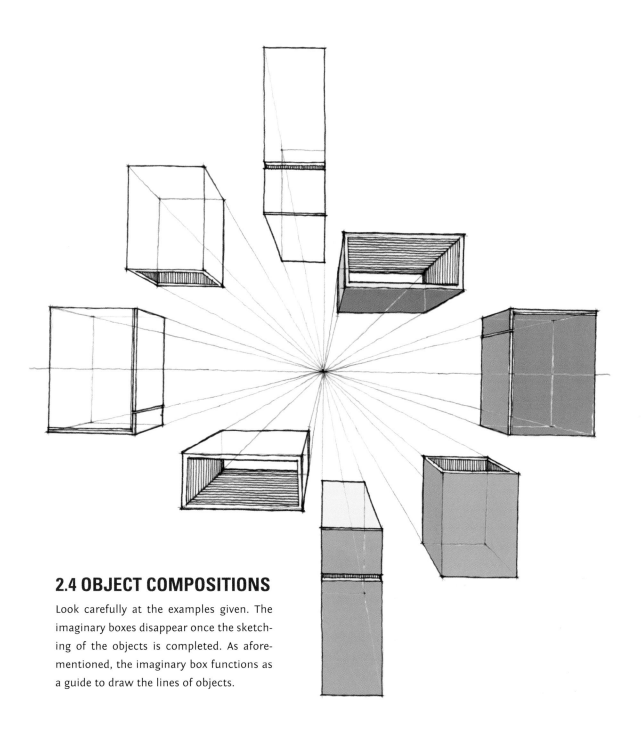

2.4 OBJECT COMPOSITIONS

Look carefully at the examples given. The imaginary boxes disappear once the sketching of the objects is completed. As aforementioned, the imaginary box functions as a guide to draw the lines of objects.

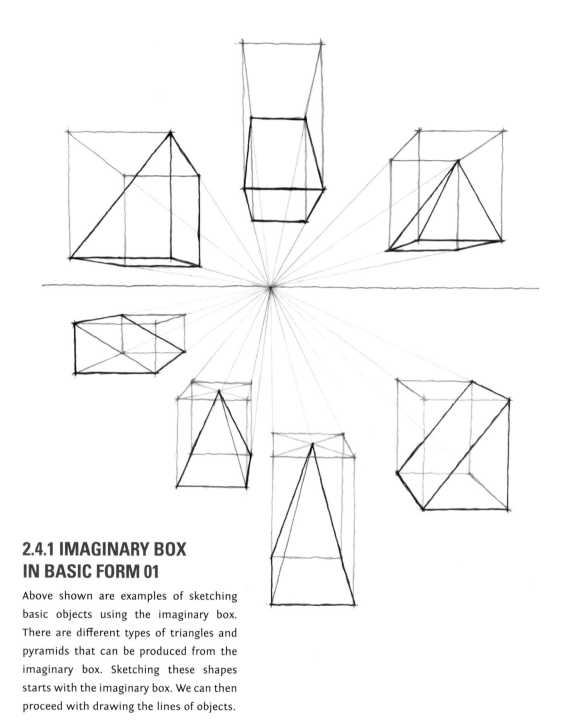

2.4.1 IMAGINARY BOX
IN BASIC FORM 01

Above shown are examples of sketching basic objects using the imaginary box. There are different types of triangles and pyramids that can be produced from the imaginary box. Sketching these shapes starts with the imaginary box. We can then proceed with drawing the lines of objects.

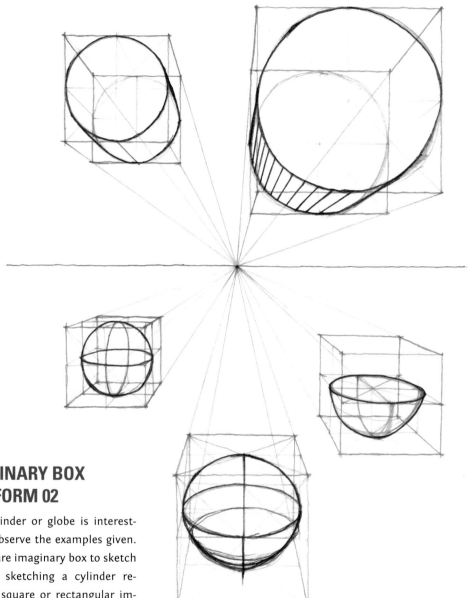

2.4.2 IMAGINARY BOX
IN BASIC FORM 02

Sketching a cylinder or globe is interesting. Carefully observe the examples given. You need a square imaginary box to sketch a globe, while sketching a cylinder requires either a square or rectangular imaginary box.

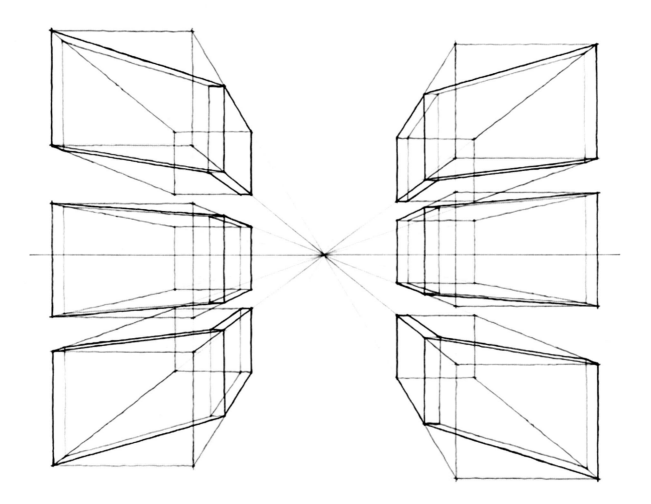

2.4.3 IMAGINARY BOX IN BASIC FORM 03

The next step is to sketch and understand the process of combining shapes inside one imaginary box. Grasping this idea and technique is important in enabling an artist or a designer to deal with complex compositions. The procedure here is to sketch an imaginary box based on the existing vanishing point and the horizon line (at the eye level).

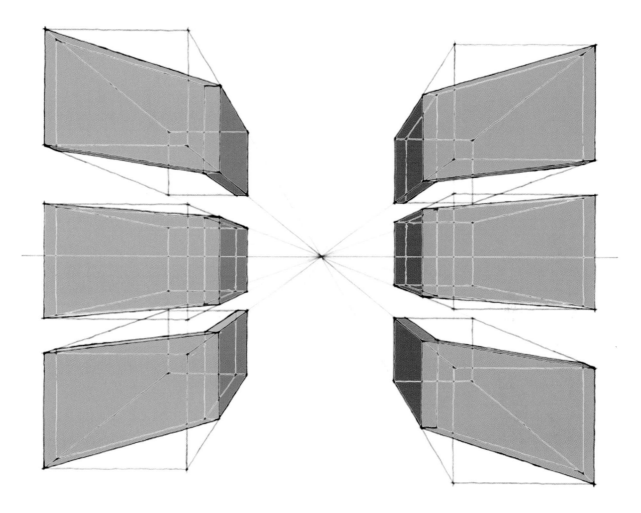

Look carefully at the surfaces of the objects as they react to the setting of the imaginary box. Different colour tones are used to show how the surfaces of the objects change once they are sketched using the imaginary boxes. The vanishing point and horizon line influence these changes.

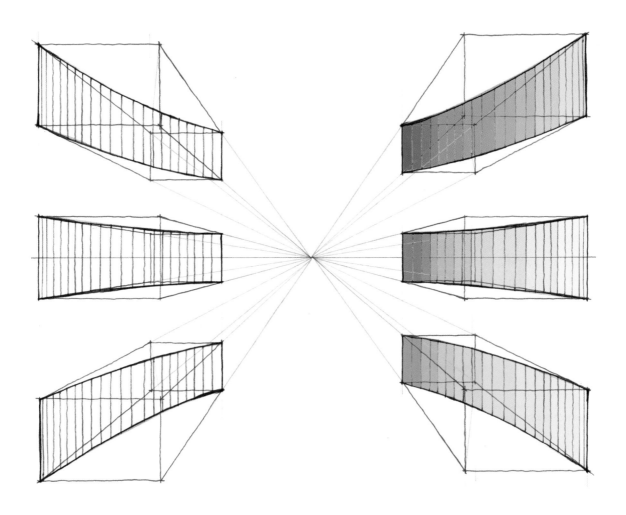

2.4.4 IMAGINARY BOX IN BASIC FORM 04

Sketching a curved surface becomes an easy task when using the imaginary box as a guide. Observe the examples given. All the curved surfaces are sketched using imaginary boxes. Colours are used to convey the curve gradient of each surface as it reacts to the vanishing point and horizon line.

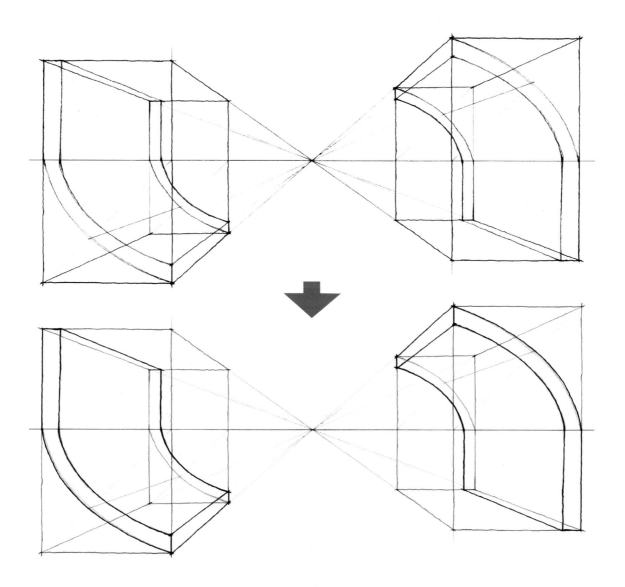

2.4.5 IMAGINARY BOX IN BASIC SHAPE 05

Basic shape 05 is about sketching a combination of two shapes: the rectangle and curve. This process starts with an imaginary box. The box is divided into two sections for the two shapes. Next, you sketch the lines of the objects according to their positions.

2.4.6 IMAGINARY BOX
IN SETTING 01

In sketching a setting, the careful arrangement of the imaginary boxes is needed to achieve a good and desirable setting. Look carefully at how these imaginary boxes function in this setting. Be creative when filling up the imaginary boxes with objects to complete the composition.

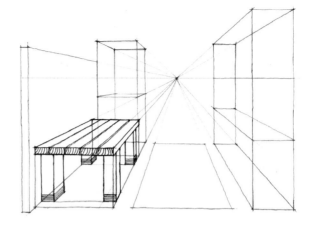

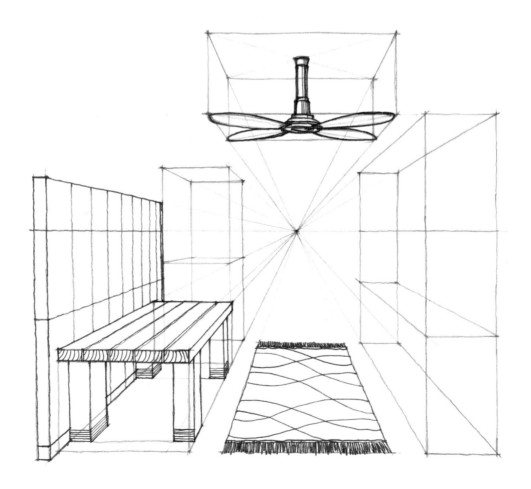

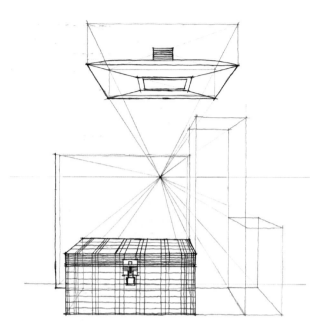

2.4.7 IMAGINARY BOX IN SETTING 02

This is all about an imaginary box in a one point perspective setting. The arrangements of the imaginary boxes are made based on your creativity and the requirements of the setting.

An artist or a designer should be able to visualize the objects that will be sketched in a setting. Observe the setting given. Look carefully at the overall composition of the imaginary boxes. All of the boxes are sketched based on a vanishing point and a horizon line.

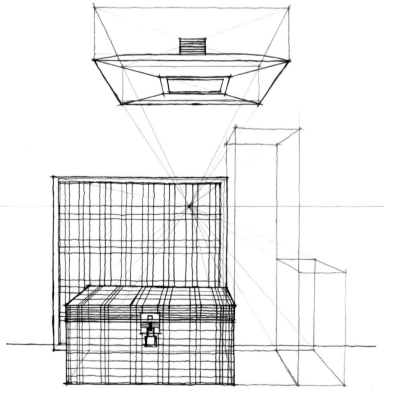

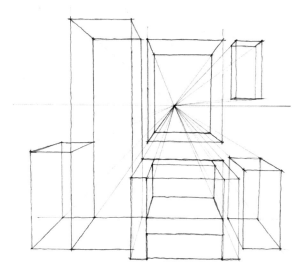

2.4.8 IMAGINARY BOX IN SETTING 03

Imaginary boxes can be sketched in any location or position in a one point perspective setting. These positions should refer to the overall composition that needs to be sketched. Look carefully at the setting given. All the imaginary boxes are sketched based on the desired layout of the artist or designer. The formation of these boxes should refer to the vanishing point.

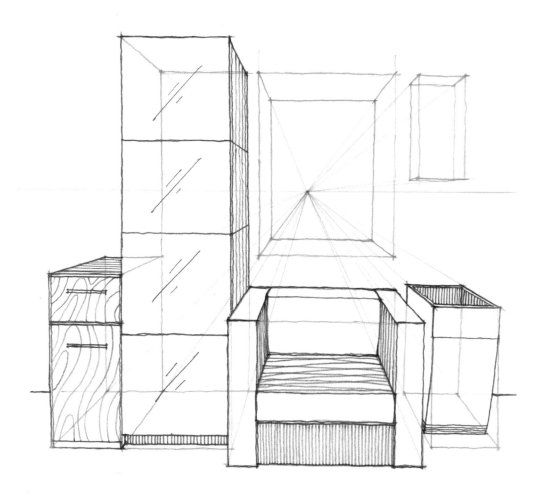

2.4.9 IMAGINARY BOX
IN SETTING 04

The size of an imaginary box sketched in a setting depends on the scale and proportion of an object. Look carefully at the setting given. The size of the imaginary box of a door is based on the scale and proportion of the desired door to be sketched. This concept of sketching any imaginary box can be applied to other objects in a setting.

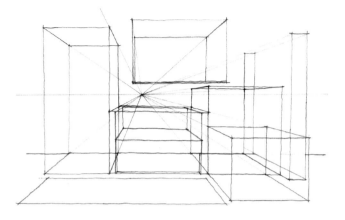

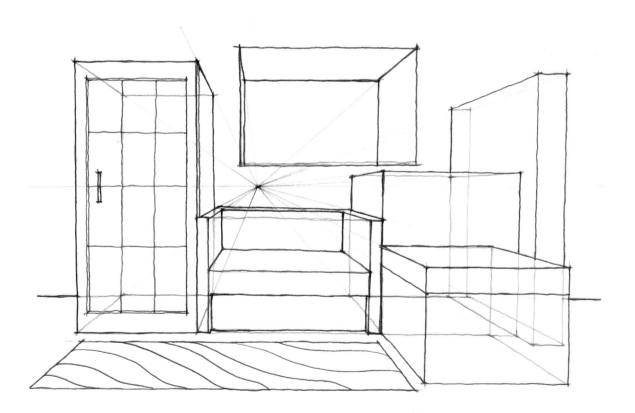

CHAPTER THREE
Basic Composition In One Point Perspective

3.1 INTRODUCTION

This chapter discusses the process of sketching basic compositions using the imaginary box concept in one point perspective setting. This includes basic compositions that will be demonstrated to further understand the formation of compositions using imaginary boxes. This chapter also shows the importance of the vanishing points and horizon line in sketching object compositions.

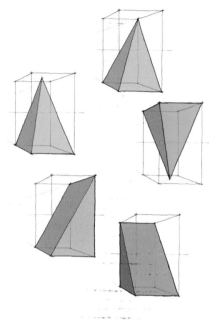

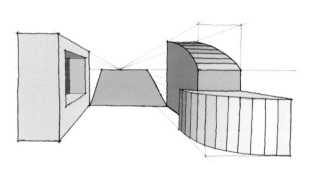

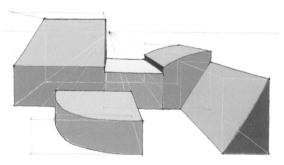

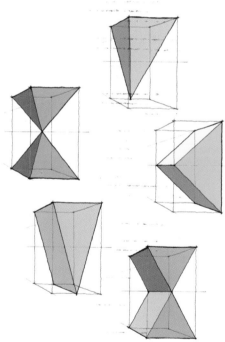

A few of the examples of basic compositions sketched using imaginary boxes

3.2 ONE POINT PERSPECTIVE SETTINGS: SINGLE OBJECT

Here are three one point perspective settings to demonstrate the sketcing process of basic compositions. The various perspective settings used in the exercises offer plenty of ideas and opportunities that imaginary boxes provide. The settings are produced based on the position of the horizon line and the sizes of the imaginary boxes. The positions of the horizon lines will influence the angle of the objects sketched, while the size of the imaginary box will influence object formation. Observe the three one point perspective settings given. Look carefully at the positions of the horizon lines in reference to the composition of the imaginary boxes.

SETTING 1:
The horizon line is located below the object composition. In this view, the bottom of the object's surfaces can be seen clearly.

SETTING 2:
The horizon line is located in the middle of the object composition. In this view, the side surfaces of the object composition can be seen clearly.

SETTING 3:
The horizon line is located above the object composition. In this view, the top of the object's surfaces can be seen clearly.

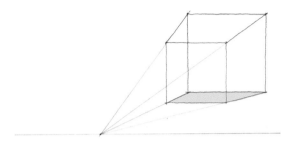

Setting 1: *Horizon line is located below the object composition*

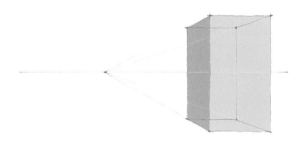

Setting 2: *Horizon line is located in the middle of the object composition*

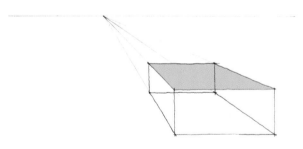

Setting 3: *Horizon line is located at the above part of the object composition*

3.2.1 BASIC COMPOSITION 01

A triangle is an interesting form to sketch. The first step is to sketch the imaginary box. Then, decide the type of triangle to be sketched in the imaginary box. Observe the line formations that shape the different triangles. It is also important to pay attention to position of the horizon line and vanishing point.

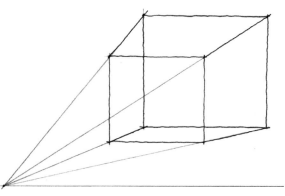

Setting 1: *One point perspective setting*

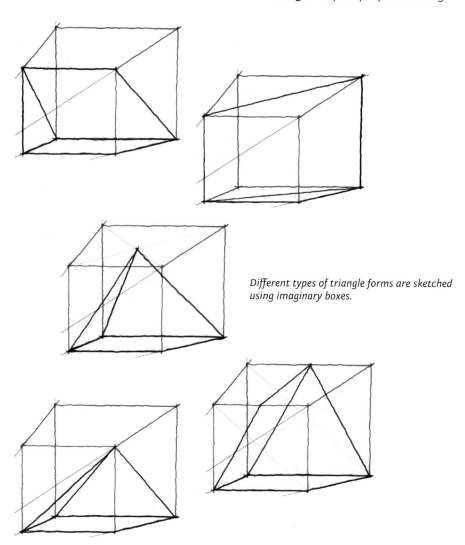

Different types of triangle forms are sketched using imaginary boxes.

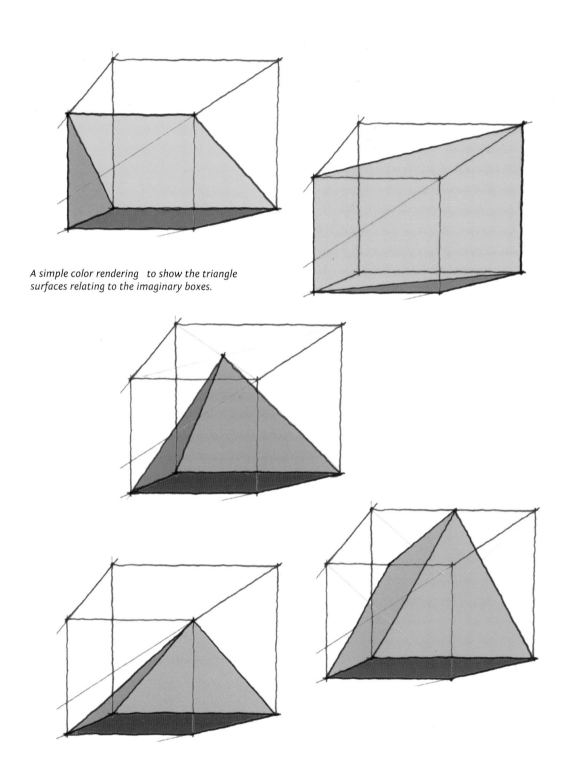

A simple color rendering to show the triangle surfaces relating to the imaginary boxes.

3.2.2 BASIC COMPOSITION 02

These are sketches of other triangles that are guided by the imaginary boxes. Observe the surfaces of the triangles in relation to the positions of the vanishing point and the horizon line. The formation of the surfaces becomes easier with the aid of imaginary boxes: lines are easily projected and well-guided to shape the triangles.

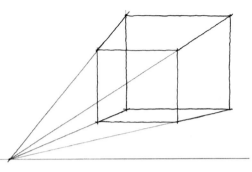

Setting 1: *One point perspective setting*

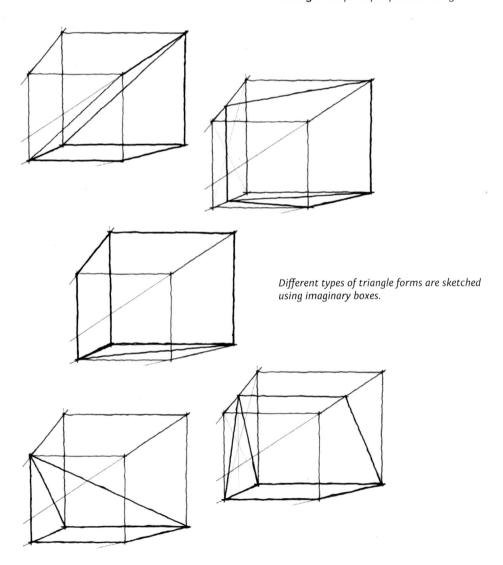

Different types of triangle forms are sketched using imaginary boxes.

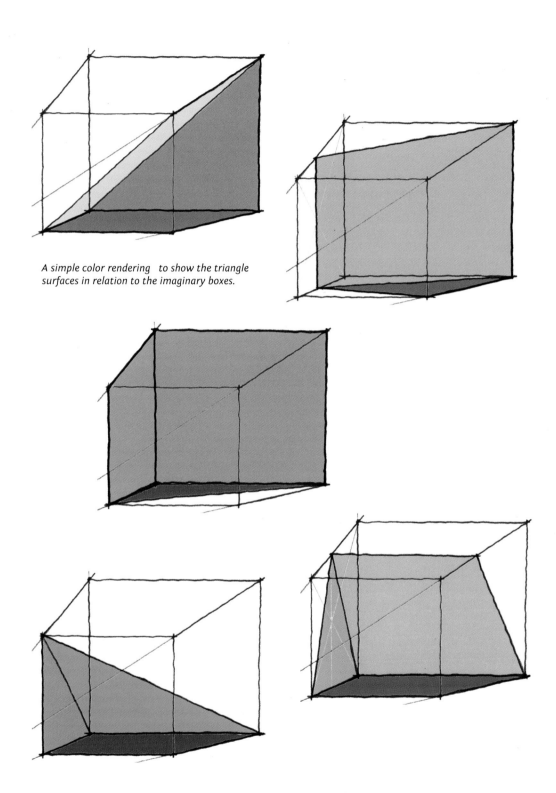

A simple color rendering to show the triangle surfaces in relation to the imaginary boxes.

3.2.3 BASIC COMPOSITION 03

These are the examples of curved object compositions. Each of the compositions' character is formed from the curved lines. It is important to draw the curved lines properly as they will influence the final composition. Sketching curved lines becomes a lot easier when imaginary boxes are guiding you. Observe all the curved lines from the objects in relation to the imaginary box.

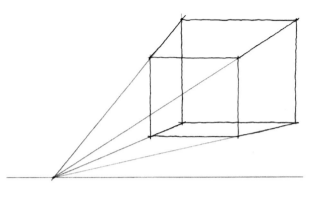

Setting 1: *One point perspective setting*

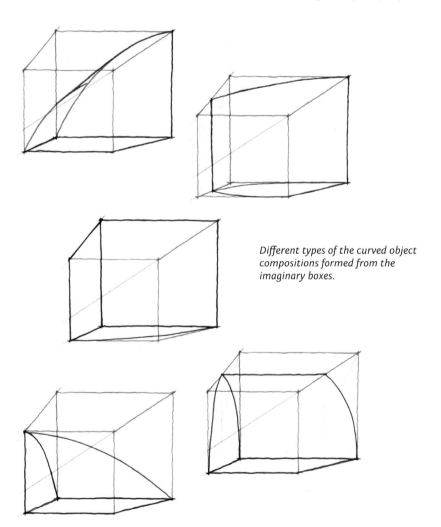

Different types of the curved object compositions formed from the imaginary boxes.

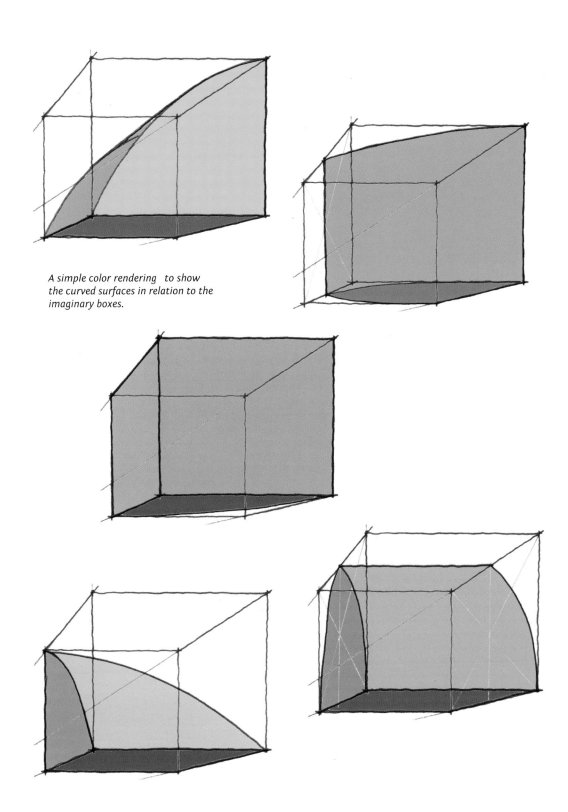

A simple color rendering to show the curved surfaces in relation to the imaginary boxes.

3.2.4 BASIC COMPOSITION 04

These are other examples of curved object compositions. More concentration is needed when sketching curved lines, as compared to straight lines. Sketching curved lines requires an understanding of the curvature of the objects' surfaces with reference to the one point perspective setting and imaginary box. Observe the examples given. Imaginary boxes govern the curved lines that have been sketched.

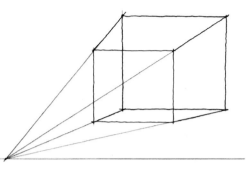

Setting 1: *One point perspective setting*

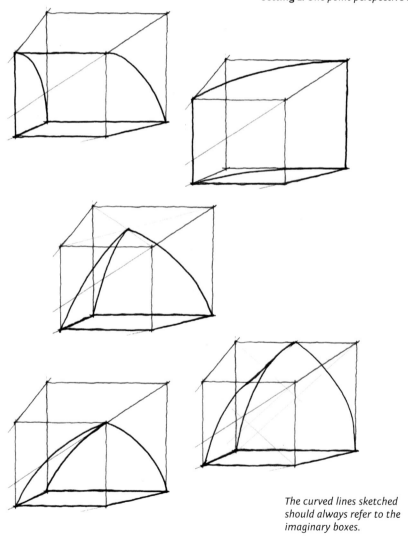

The curved lines sketched should always refer to the imaginary boxes.

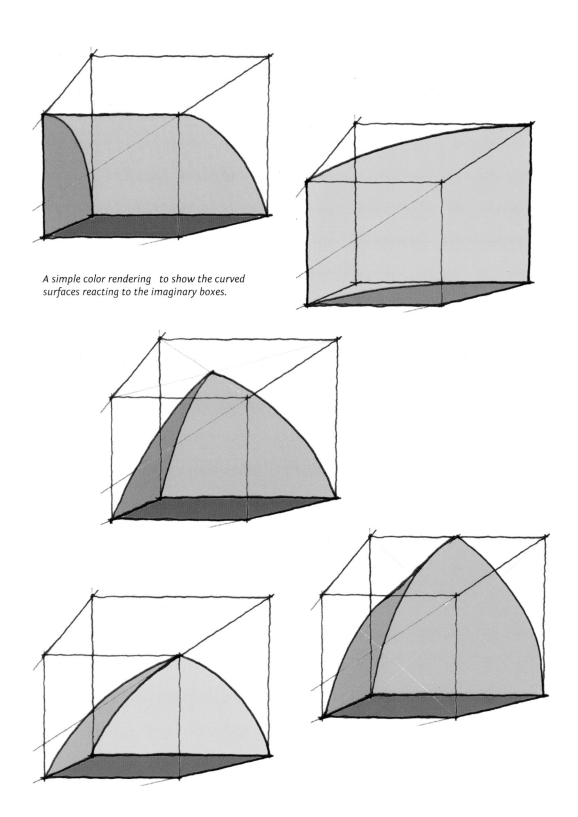

A simple color rendering to show the curved surfaces reacting to the imaginary boxes.

3.2.5 BASIC COMPOSITION 05

Sketching a triangle using an imaginary box is an interesting process. As demonstrated in the examples given, there are many types of triangles that can be sketched using an imaginary box. Here, the horizon line is located in the middle of the object composition. Observe all the triangle surfaces in relation to positions of the horizon line and vanishing point.

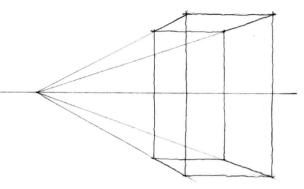

Setting 2: *One point perspective setting*

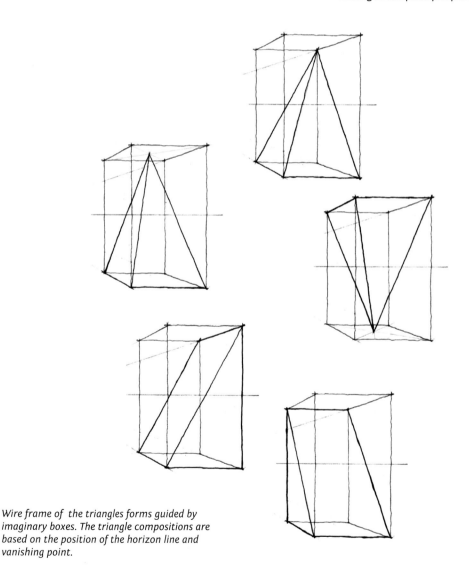

Wire frame of the triangles forms guided by imaginary boxes. The triangle compositions are based on the position of the horizon line and vanishing point.

A simple color rendering to show the triangles surfaces in relation to the horizon line and vanishing point.

3.2.6 BASIC COMPOSITION 06

The exploration of sketching basic compositions continues with more examples related to triangles. Observe the sketching of these forms using imaginary boxes. The frames of the imaginary boxes guide the projection of all the lines. As the horizon line is located in the middle, the top and bottom surfaces of the object compositions cannot be seen from this angle.

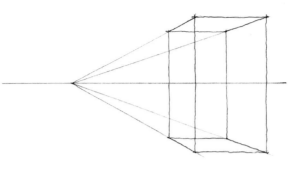

Setting 2: *One point perspective setting*

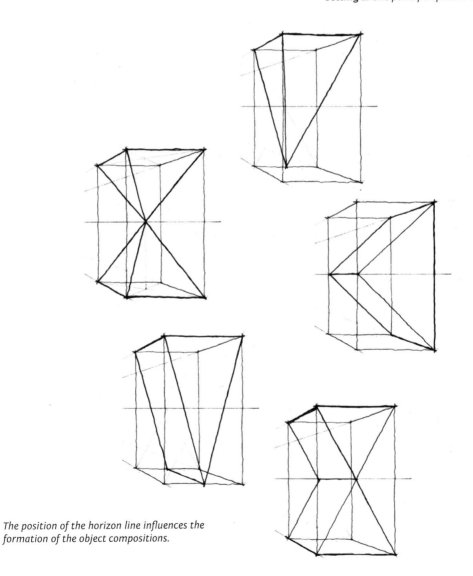

The position of the horizon line influences the formation of the object compositions.

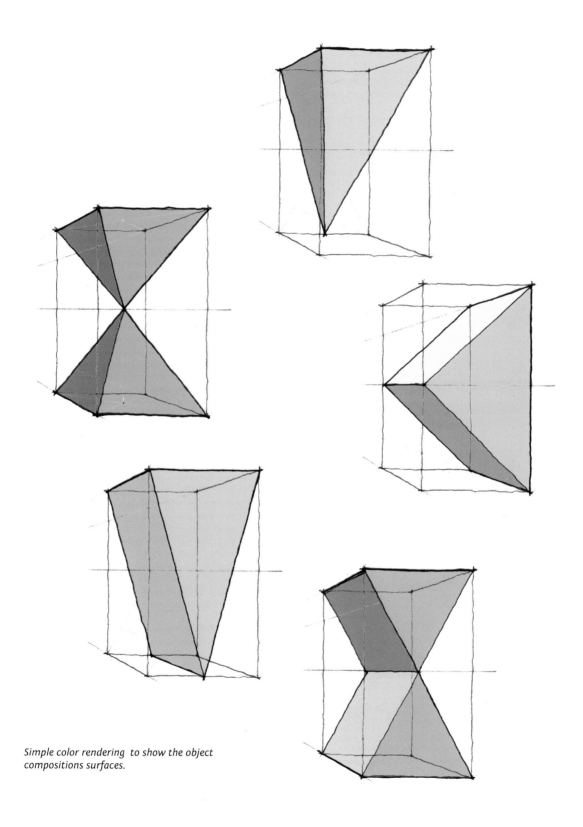

Simple color rendering to show the object compositions surfaces.

3.2.7 BASIC COMPOSITION 07

The imaginary boxes guide each of the object compositions. Understanding how to sketch curved or straight lines in their positions produces quality compositions. Observe the examples given. Each of the lines has its own character in forming an object.

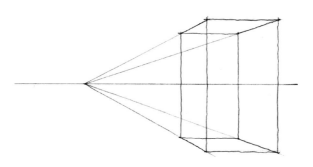

Setting 2: *One point perspective setting*

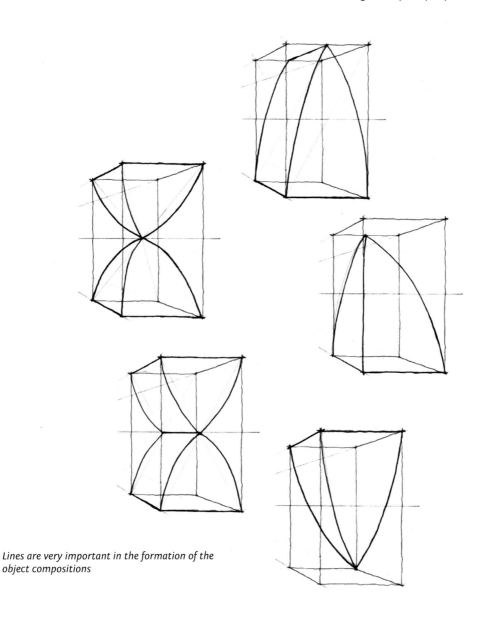

Lines are very important in the formation of the object compositions

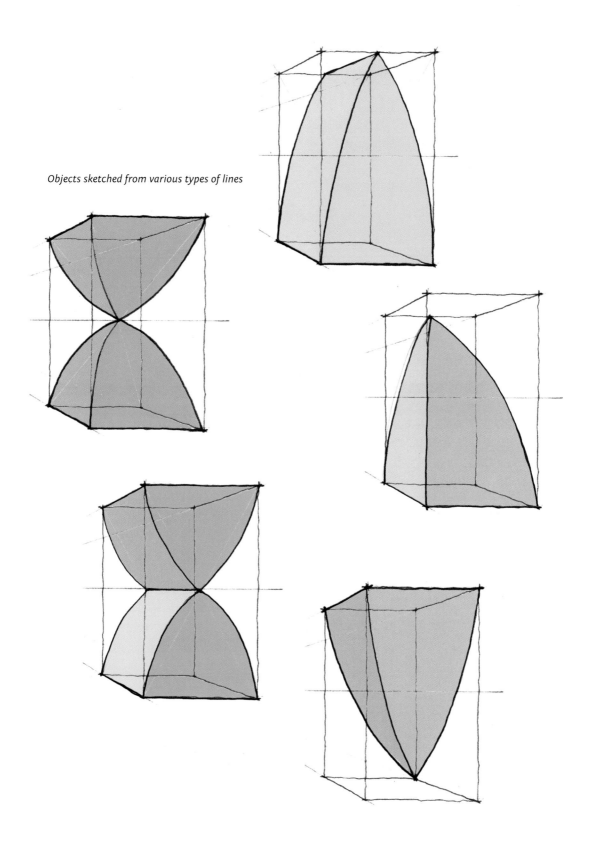

Objects sketched from various types of lines

3.2.8 BASIC COMPOSITION 08

Wonders can be done with lines and the imaginary box. This is another set of examples of objects sketched using curved lines and the imaginary box. Each curved line has its own curvature to achieve the desired forms. Being able to sketch well-defined curved lines is necessary to produce well-drawn curved objects. Observe the examples given.

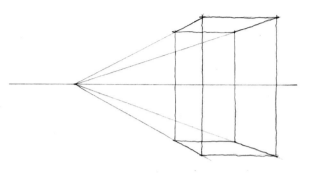

Setting 2: *One point perspective setting*

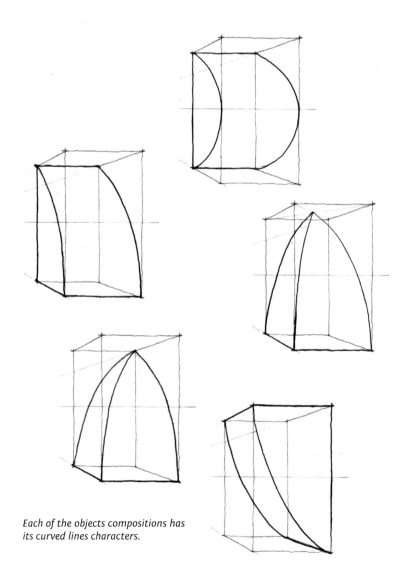

Each of the objects compositions has its curved lines characters.

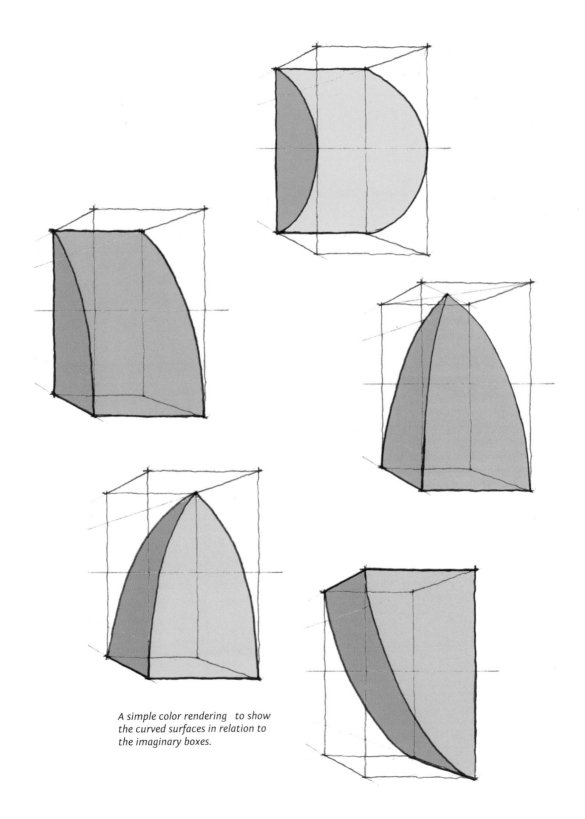

A simple color rendering to show the curved surfaces in relation to the imaginary boxes.

3.2.9 BASIC COMPOSITION 09

These object compositions are meant to demonstrate the outcome of setting 3. The position of the horizon line is located above the object. Various types of triangles are sketched using the imaginary boxes created from the setting. Based on this setting, the surfaces at the top of the the objects can be seen clearly.

Setting 3: *One point perspective setting*

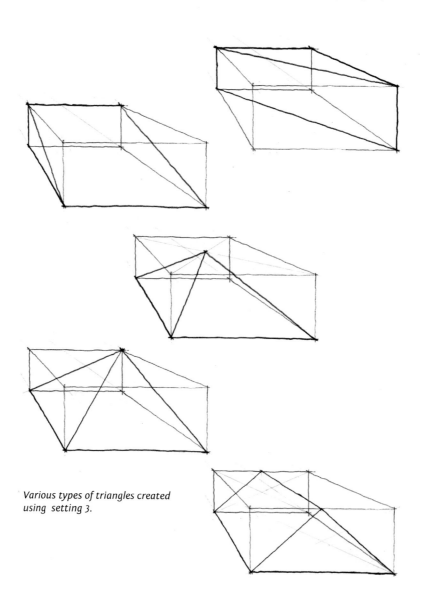

Various types of triangles created using setting 3.

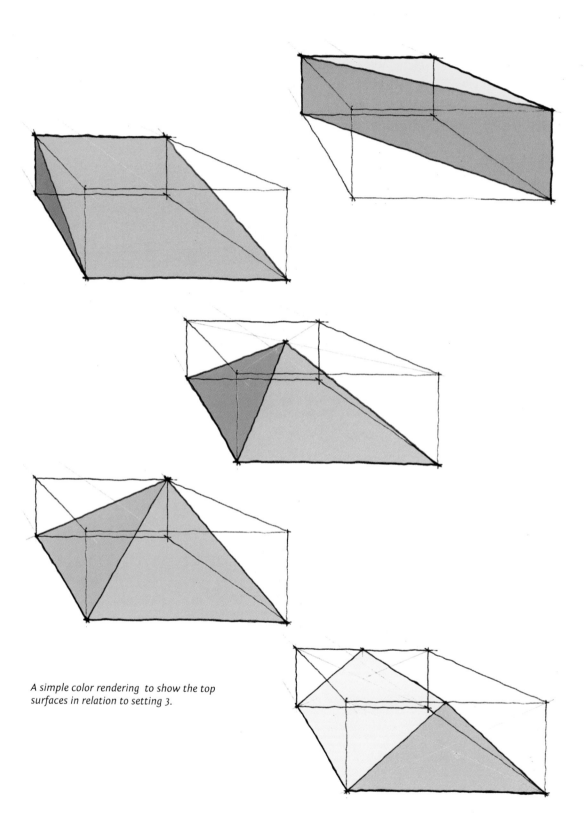

A simple color rendering to show the top surfaces in relation to setting 3.

3.2.10 BASIC COMPOSITION 10

The imaginary box makes the process of sketching an object easier. It guides the line projections that form objects. The imaginary box also creates the boundary for a composition to fulfill the requirements of a perspective setting.

For example, the imaginary box creates a boundary for the formation of an object's surfaces. Observe the examples given, which use the imaginary boxes as their objects' boundaries.

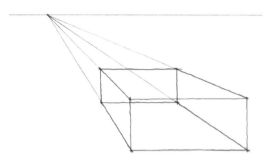

Setting 3: *One point perspective setting*

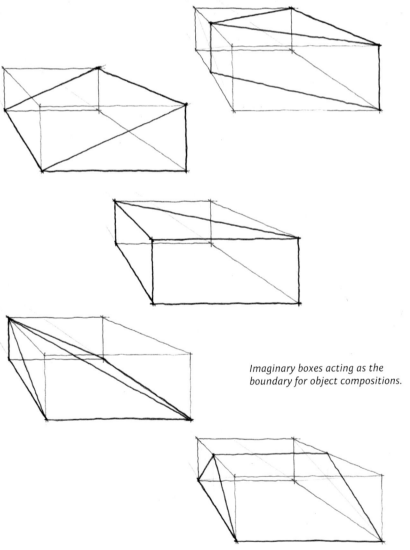

Imaginary boxes acting as the boundary for object compositions.

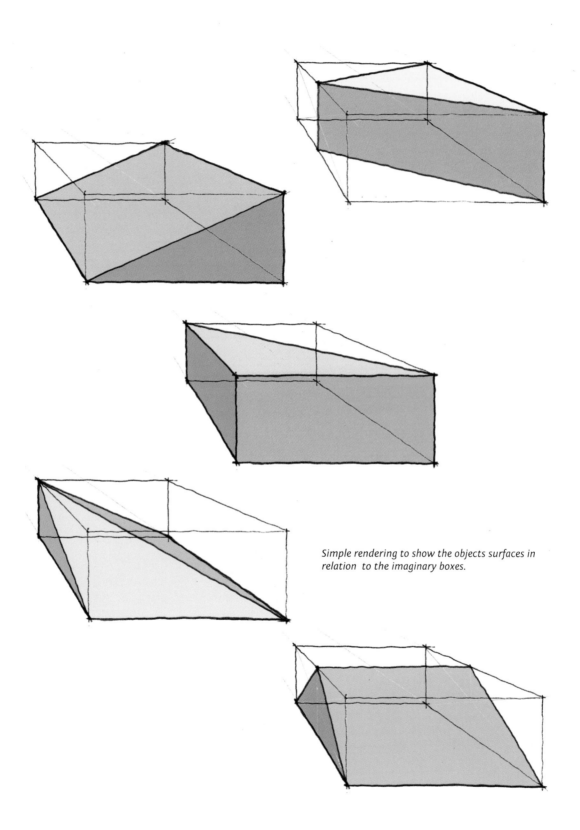

Simple rendering to show the objects surfaces in relation to the imaginary boxes.

3.2.11 BASIC COMPOSITION 11

Sketching curved objects becomes easier with the guidance of the imaginary box. The examples given are the curved object compositions that are sketched based on setting 3. In these examples, the top surfaces can be seen clearly. The process of sketching these compositions applies equally to other settings. However, you must be very careful in achieving the right curvature for each form. The curvatures must be in accordance with the objects' positions in relation to the horizon line and vanishing point.

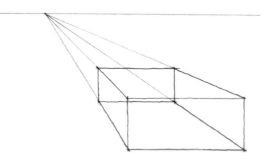

Setting 3: *One point perspective setting*

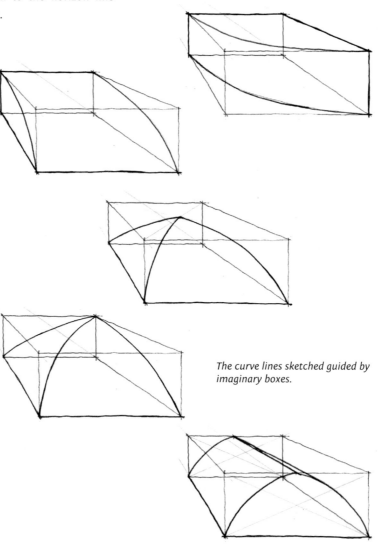

The curve lines sketched guided by imaginary boxes.

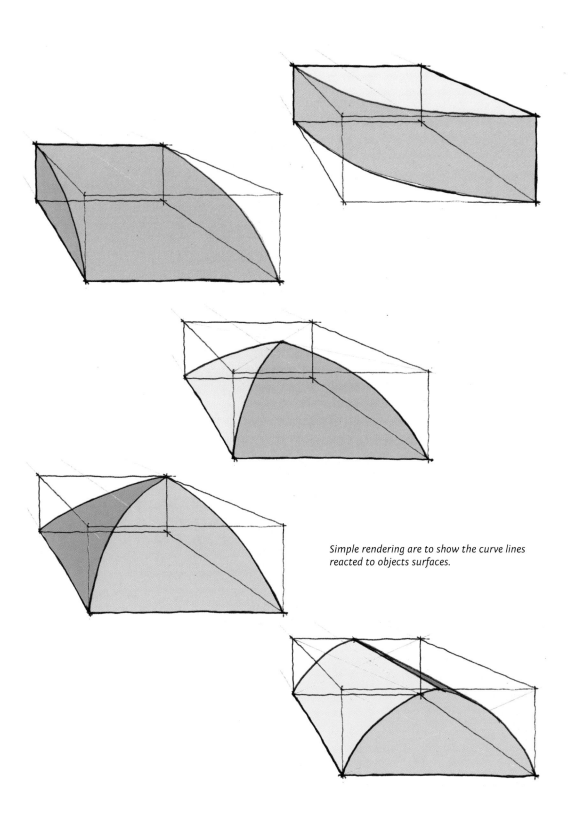

*Simple rendering are to show the curve lines
reacted to objects surfaces.*

3.2.12 BASIC COMPOSITION 12

This is another set of curved surfaces in setting 3 that can be produced using the guide provided by imaginary boxes. Look carefully at how the curved lines relate to the imaginary boxes. Each line has its own curvature that needs to be carefully sketched in order to obtain the desired curved surfaces.

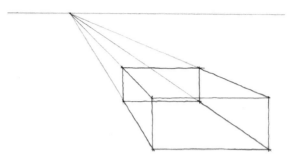

Setting 3: *One point perspective setting*

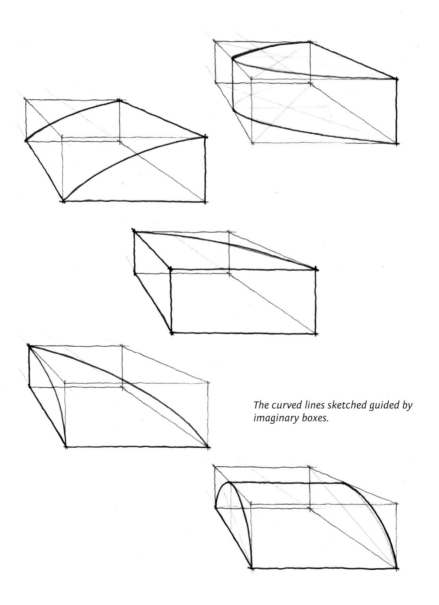

The curved lines sketched guided by imaginary boxes.

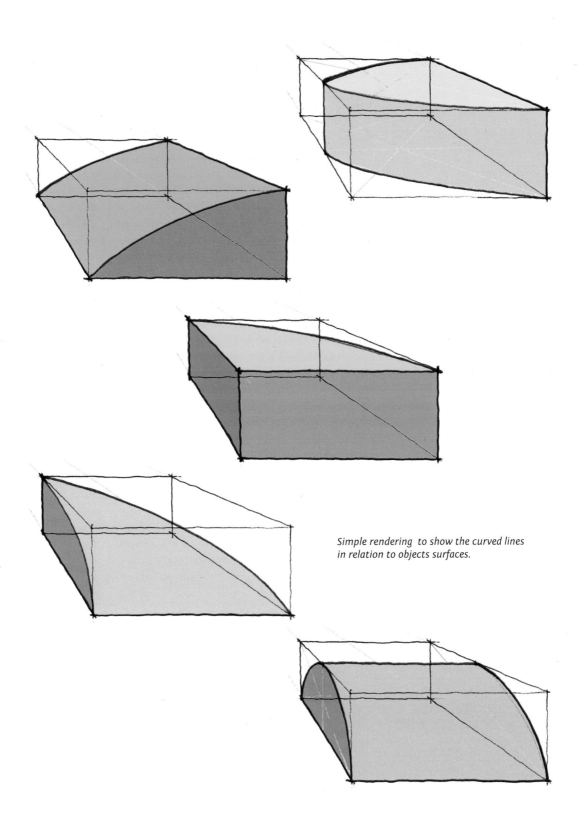

Simple rendering to show the curved lines in relation to objects surfaces.

3.3 ONE POINT PERSPECTIVE SETTINGS: MULTIPLE OBJECTS

This section demonstrates how you can sketch multiple objects in a perspective setting. There are three types of one point perspective settings employed here. The settings are:

SETTING 1:

The horizon line is located below the objects composition. The imaginary boxes are sketched above the horizon line, allowing the bottom surfaces of the objects to be clearly shown.

SETTING 2:

The horizon line is located in the middle of the objects composition. The imaginary boxes drawn will demonstrate clearly the elevation of the objects.

SETTING 3:

The horizon line is located above the objects composition. The imaginary boxes will show clearly the upper surfaces of the objects.

Setting 1: *Horizon line is located below the objects composition*

Setting 2: *Horizon line is located in the middle of the objects composition*

Setting 3: *Horizon line is located above the objects composition*

3.3.1 MULTIPLE OBJECTS 01

Sketching this composition starts with a horizon line and a vanishing point. Ensure that the horizon line is sketched below the imaginary boxes. Then, sketch the imaginary boxes in their positions based on the composition's requirements. Usually, it is good to complete the compositions of the imaginary boxes before sketching objects according to them. It is also important to make sure all the imaginary boxes sketched refer solely to the only existing vanishing point as this is an exercise in sketching in a one point perspective setting.

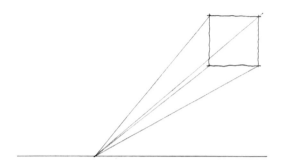

Step 1 : *formation of a horizon line and vanishing point*

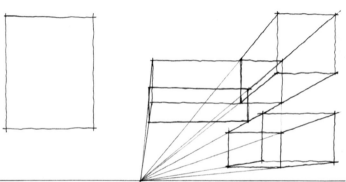

Step 2 : *the formation of imaginary boxes*

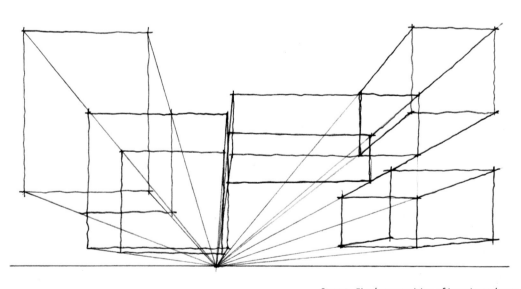

Step 3: *Final composition of imaginary boxes*

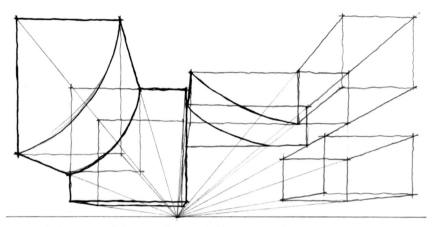

Step 4: *The formation of objects surfaces guided by imaginary boxes.*

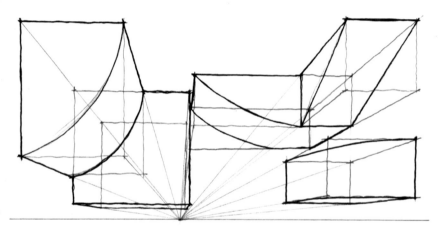

Step 5: *The final objects composition.*

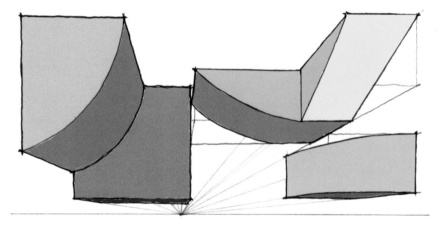

Step 6: *Colours are used to show the overall objects compositions.*

3.3.2 MULTIPLE OBJECTS 02

Imaginary boxes are very important in every perspective setting as they influence the outcome of a multiple object composition. These boxes should be sketched and formed properly. Observe the process of creating these objects using different types of surfaces.

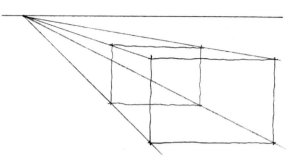

Step 1 : *formation of a horizon line and vanishing point.*

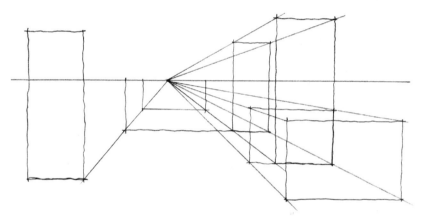

Step 2 : *the formation of imaginary boxes based on a horizon line and a vanishing point.*

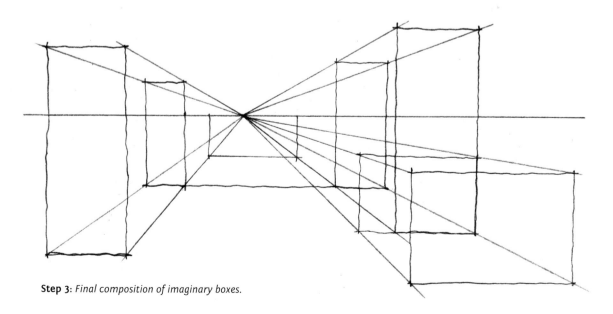

Step 3: *Final composition of imaginary boxes.*

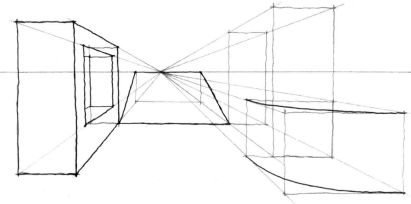

Step 4: *The objects are sketched from the imaginary boxes.*

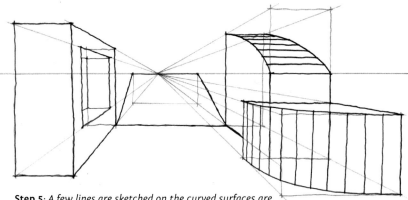

Step 5: *A few lines are sketched on the curved surfaces are to show the curvature of the surfaces.*

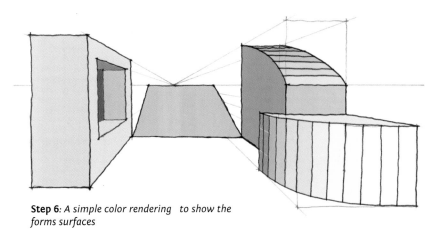

Step 6: *A simple color rendering to show the forms surfaces*

3.3.3 MULTIPLE OBJECTS 03

Sketching curved surfaces becomes more interesting when imaginary boxes are used as guides. Observe the process of forming different types of curved surfaces shown here. The curved lines should be sketched properly to get well-defined objects. Imaginary boxes of varying sizes are employed to form different types of objects. Understanding the functions of an imaginary box will enable you to sketch interesting and more complex objects.

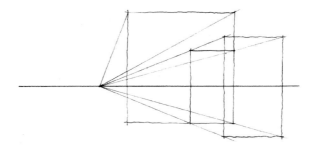

Step 1 : *formation of a horizon line and vanishing point.*

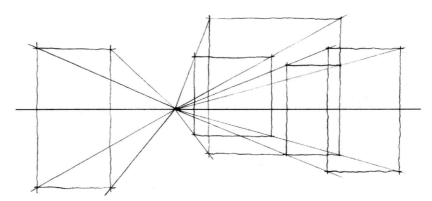

Step 2 : *the formation of imaginary boxes.*

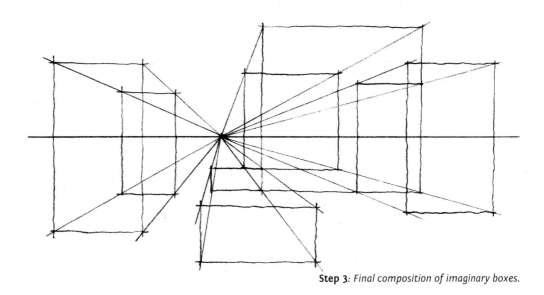

Step 3: *Final composition of imaginary boxes.*

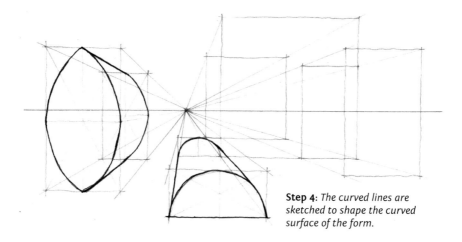

Step 4: *The curved lines are sketched to shape the curved surface of the form.*

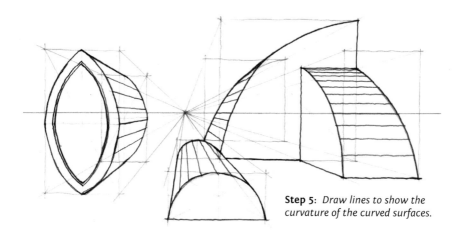

Step 5: *Draw lines to show the curvature of the curved surfaces.*

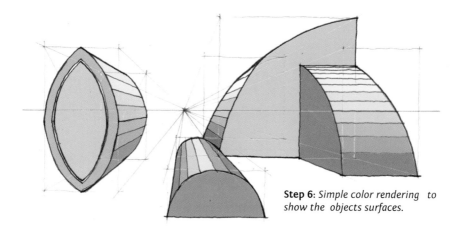

Step 6: *Simple color rendering to show the objects surfaces.*

3.3.4 MULTIPLE OBJECTS 04

The imaginary box can do wonders in creating and forming an object. This example hows the formation of triangular objects. The process starts with the formation of imaginary boxes. Plan the position of each imaginary box in the composition. In this setting, the horizon line is located above the imaginary boxes, clearly showing their top surfaces. The process of forming each triangle starts with justifying the triangle's 'peak'. Then, using the imaginary box as a guide, continue sketching its surfaces.

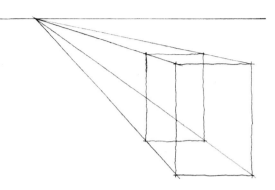

Step 1 : *formation of a horizon line and vanishing point.*

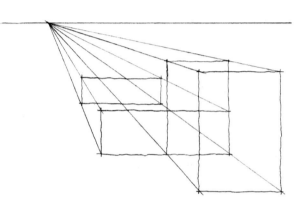

Step 2 : *the formation of imaginary boxes.*

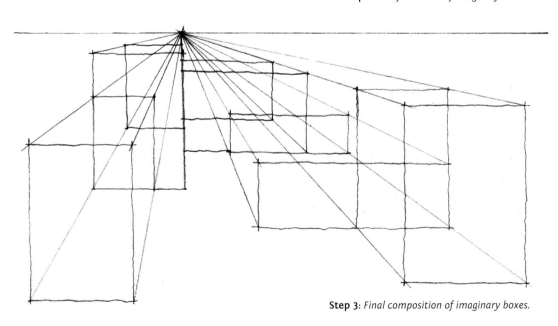

Step 3: *Final composition of imaginary boxes.*

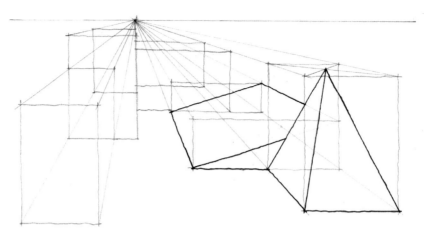

Step 4: *Two types of triangles are sketched guided by the imaginary boxes.*

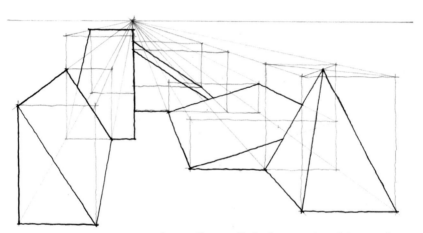

Step 5: *The overall wire frame setting of the triangles.*

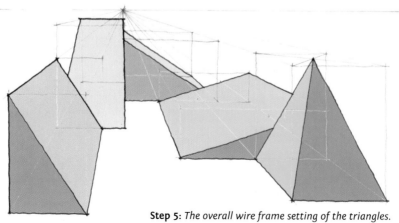

Step 5: *The overall wire frame setting of the triangles.*

3.3.5 MULTIPLE OBJECTS 05

The imaginary box can do wonders in a perspective setting. The box facilitates the formation of different objects in a perspective setting. Observe the perspective setting given. Different types of imaginary boxes are used to form the objects. The ability to justify the positions and sizes of the imaginary boxes in a perspective setting is important. This facilitates the formation of a good sketch composition.

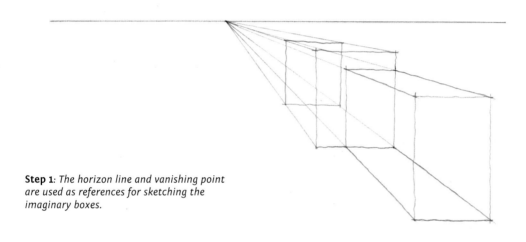

Step 1: *The horizon line and vanishing point are used as references for sketching the imaginary boxes.*

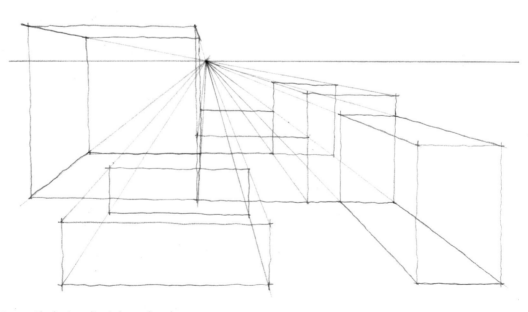

Step 2: *The horizon line is located at the upper level of the forms.*

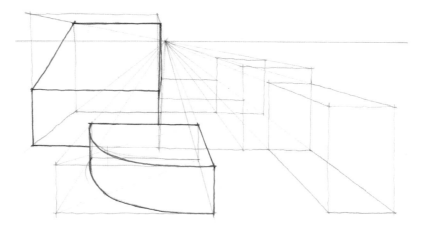

Step 3: *two objects are sketched guided by the imaginary boxes.*

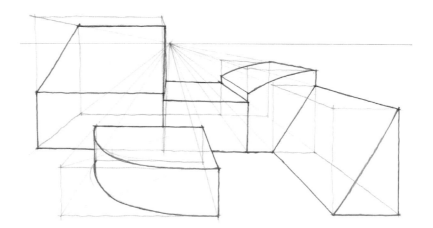

Step 4: *The overall objects wire frames.*

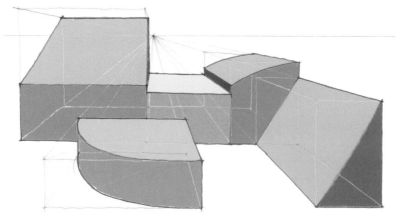

Step 6: *A simple color rendering to show the overall basic form composition.*

3.3.6 MULTIPLE OBJECTS 06

Sketching complex objects using the imaginary line is an interesting process. It requires creativity in handling the imaginary box, which acts as a guide to produce the complex object. The same process is applied to produce the imaginary boxes setting. Then, continue by sketching the complex objects composition. Observe the formation of the wave and curved surfaces in the perspective setting given. These objects are sketched guided by the imaginary boxes prepared in the previous process.

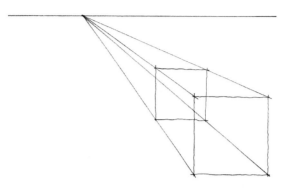

Step 1 : *formation of a horizon line and vanishing point.*

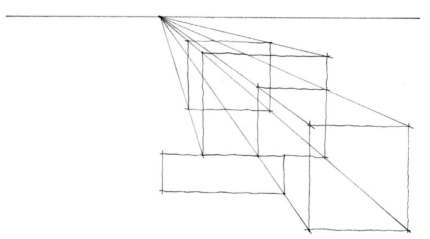

Step 2 : *the formation of imaginary boxes.*

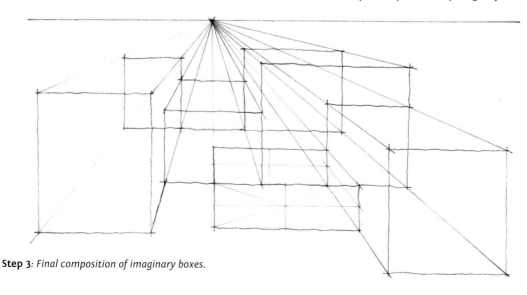

Step 3: *Final composition of imaginary boxes.*

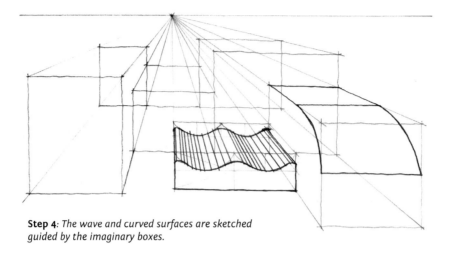

Step 4: *The wave and curved surfaces are sketched guided by the imaginary boxes.*

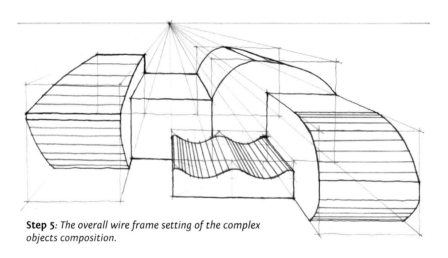

Step 5: *The overall wire frame setting of the complex objects composition.*

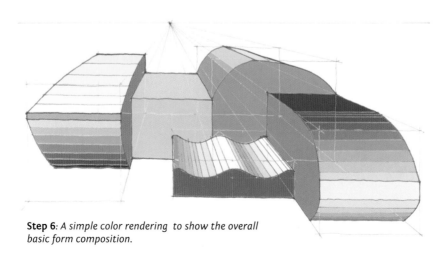

Step 6: *A simple color rendering to show the overall basic form composition.*

CHAPTER FOUR
Creative Composition In One Point Perspective

4.1 INTRODUCTION

This chapter discusses the process of sketching creative compositions in a one point perspective setting. Imaginary boxes guide this sketching process. This chapter demonstrates the sheer range of creative compositions possible in order to further explore the functions of the imaginary box. Although this chapter focuses on sketching in a one point perspective setting, it also gives examples of different perspective settings to highlight the functions of the horizon line and vanishing point.

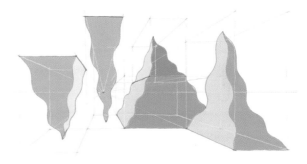

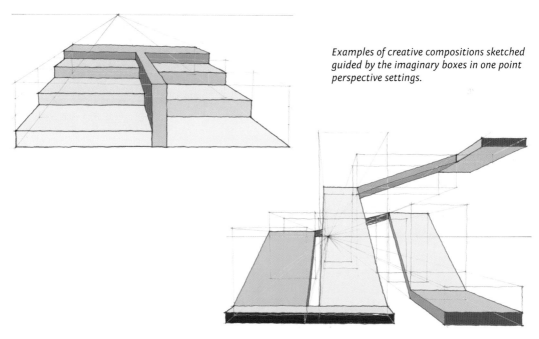

Examples of creative compositions sketched guided by the imaginary boxes in one point perspective settings.

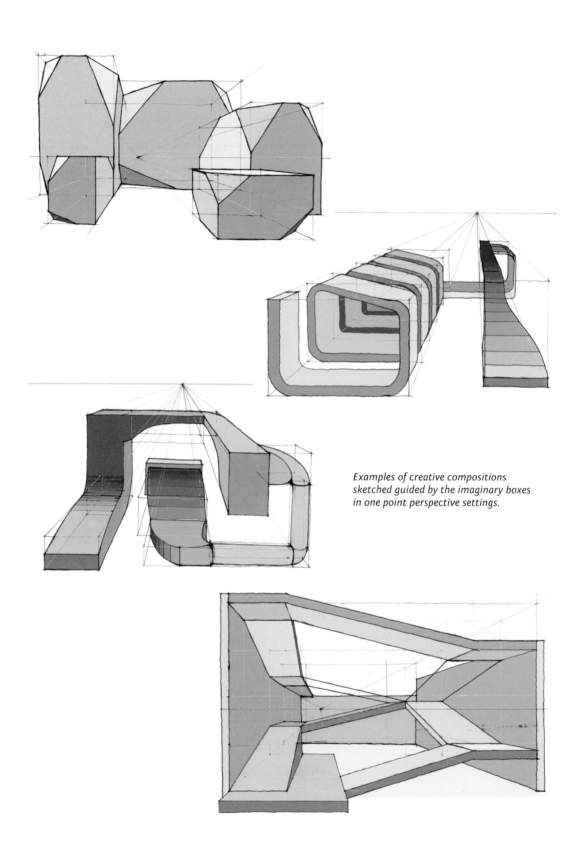

*Examples of creative compositions
sketched guided by the imaginary boxes
in one point perspective settings.*

4.1.1 CREATIVE COMPOSITION 01

Many types of surfaces are involved in the process of sketching vari-
ous forms. Observe how the forms are sketched using the imaginary
boxes as guides. Creativity and skill is needed to deal with different
forms. An ability to produce quality lines is also important in raising
the quality of a sketch.

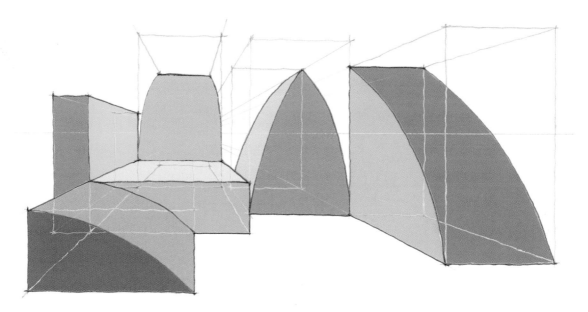

Creative composition 01

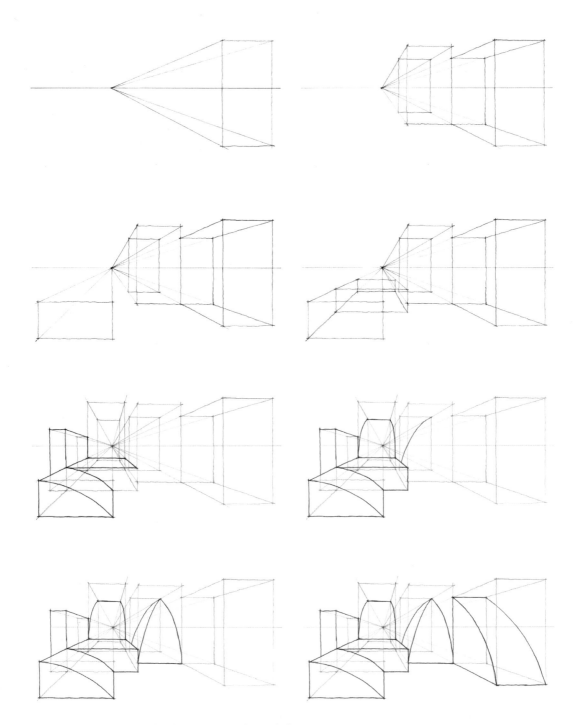

The step by step process of sketching square and curved objects.

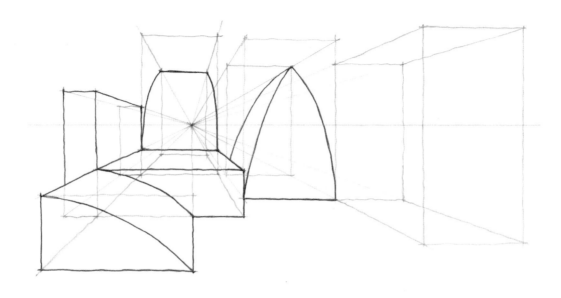

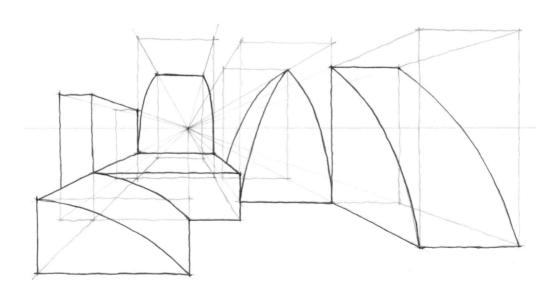

The wireframe of the objects sketched guided by the imaginary boxes.

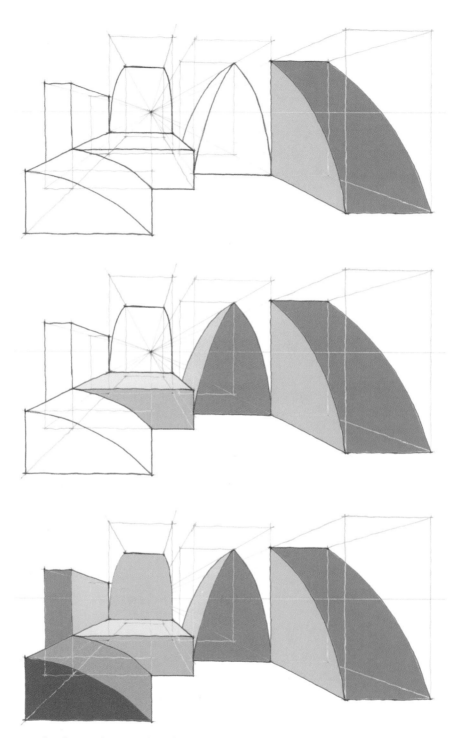

A simple colour rendering to show the formation of the objects surfaces in the composition.

4.1.2 CREATIVE COMPOSITION 02

This composition explores ideas on types of surfaces in a one point perspective setting. The process begins with the formation of the imaginary boxes. Then, we continue with sketching an object that is located at the front of the composition. Observe each step of the process. Every object is sketched using the imaginary boxes as guides.

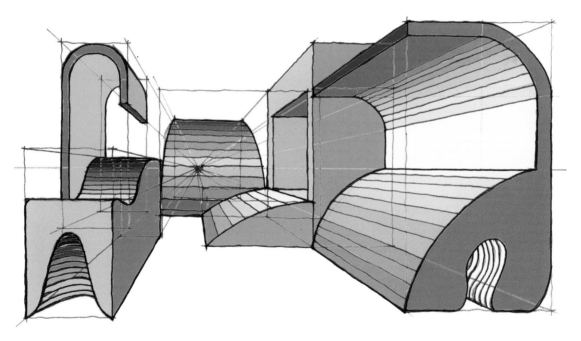

Creative composition 02

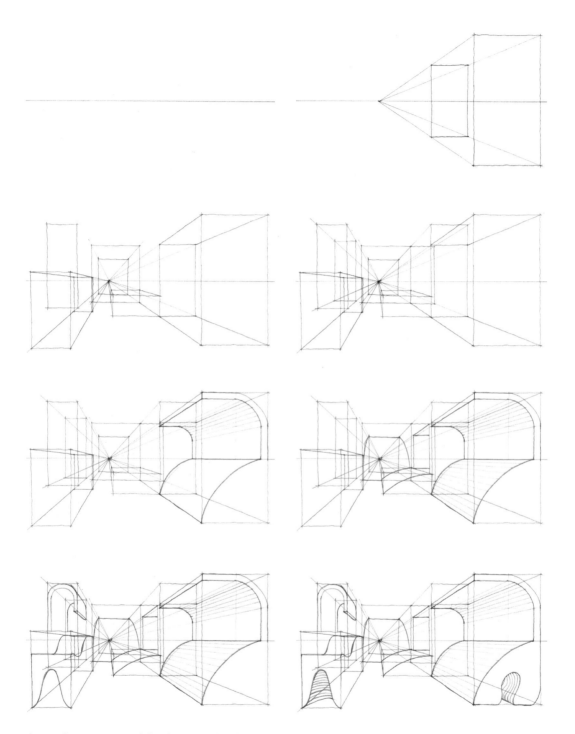

The step by step process of sketching complex objects composition.

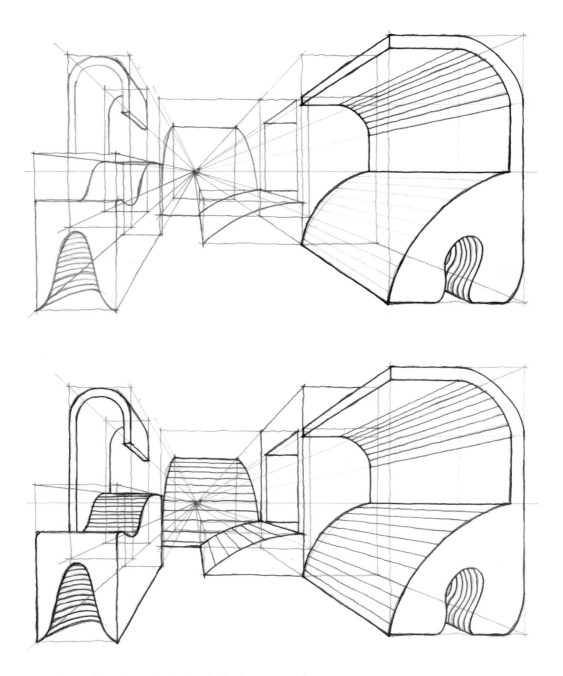

The wireframe of the objects sketched guided by the imaginary boxes.

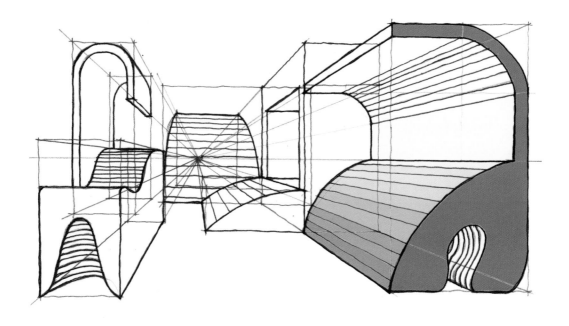

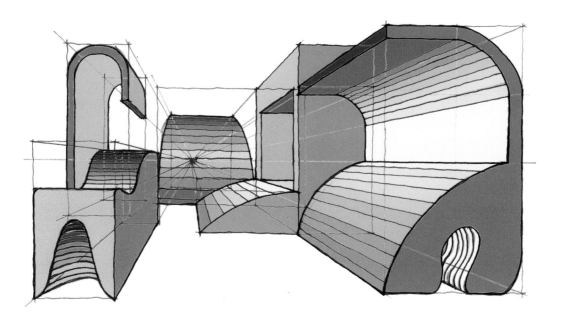

A simple colour rendering to show the formation of the objects surfaces in the composition.

4.1.3 CREATIVE COMPOSITION 03

Sketching a square box is easy when an imaginary box is guiding you. On the other hand, sketching an object with uneven surfaces is challenging. The key to this task is the artist's creativity and skill in employing the imaginary box. Observe each step of the process to see how the imaginary boxes are used to form the compositions.

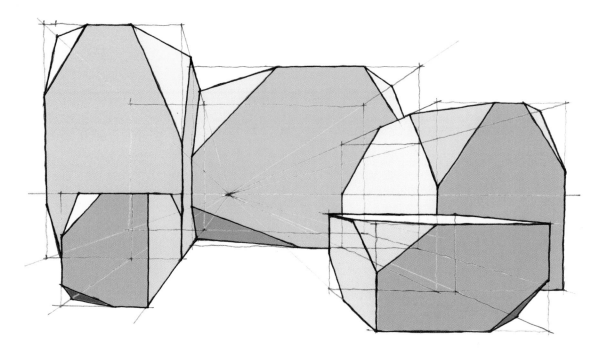

Creative composition 03

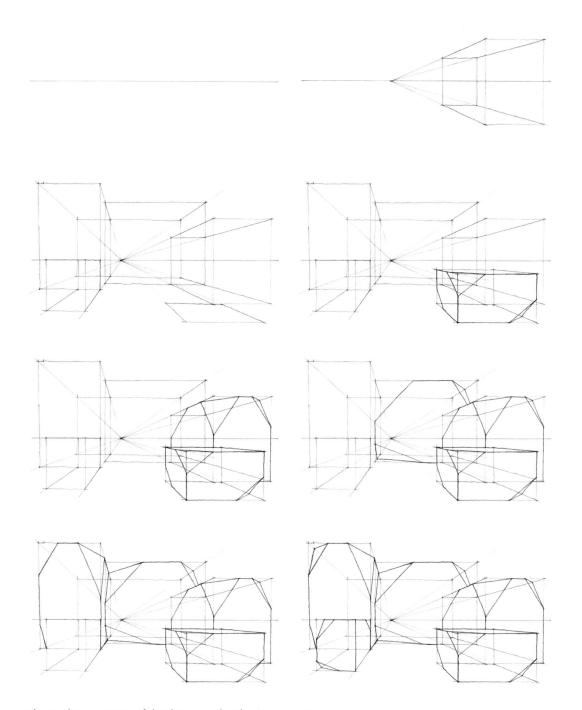

The step by step process of sketching complex objects composition.

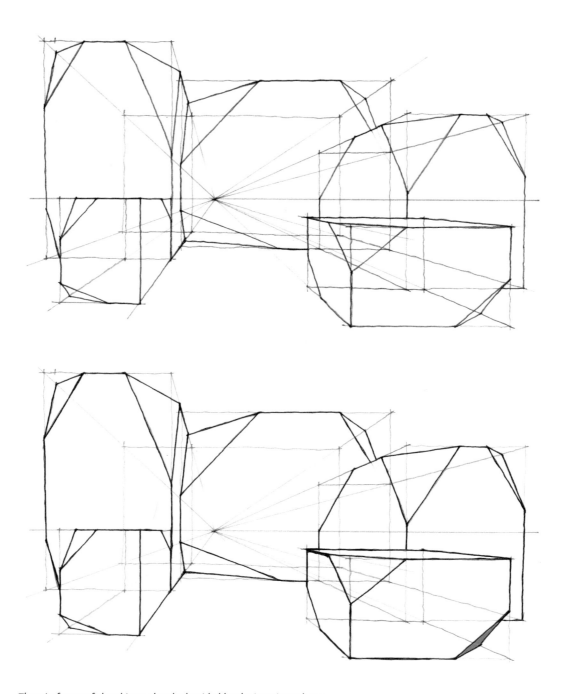

The wireframe of the objects sketched guided by the imaginary boxes.

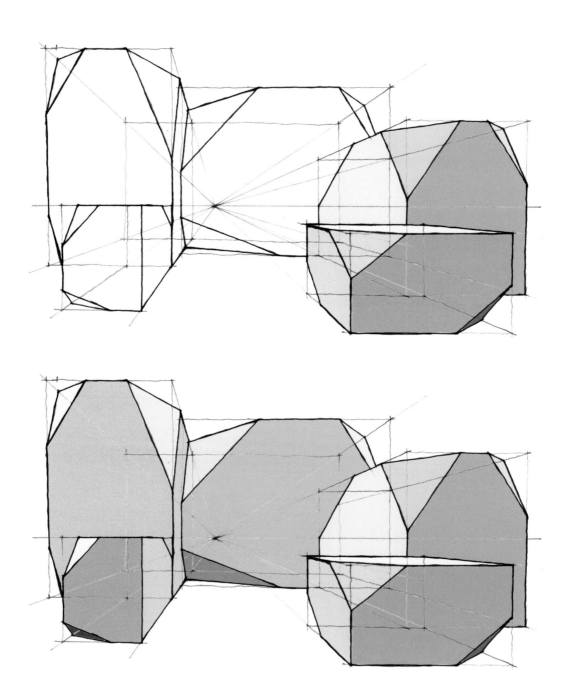

A simple colour rendering to show the formation of the objects surfaces in the composition.

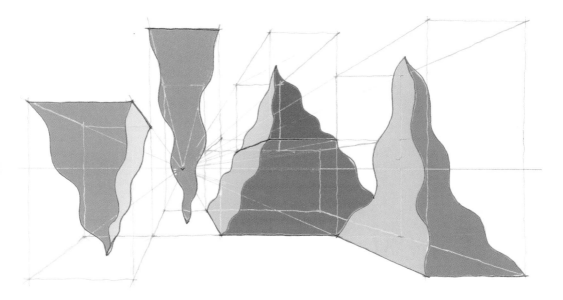

Creative composition 04

4.1.4 CREATIVE COMPOSITION 04

Many types of forms can be created using the imaginary box as a guide. Examples of these forms are the fluid forms shown here, which are produced using a set of wave lines. Observe how these forms are sketched. The process starts by locating the 'peak' point of each object. Wave lines are then sketched towards each peak.

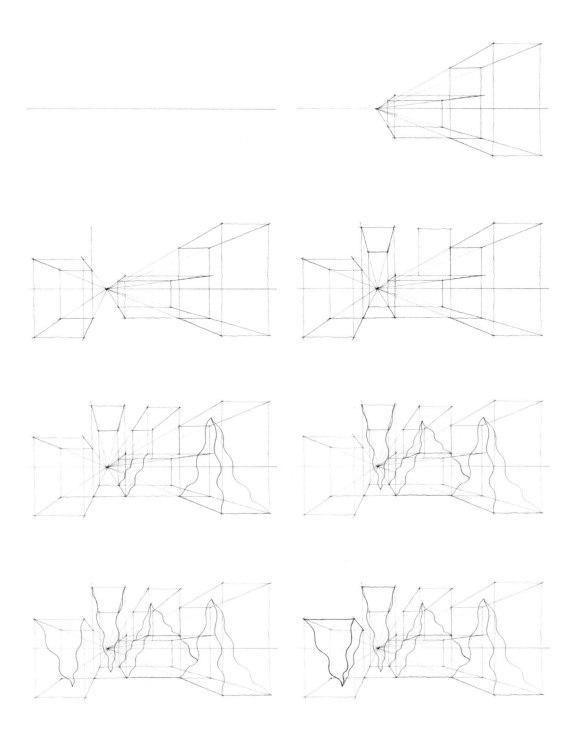

The step by step process of sketching the complex objects composition.

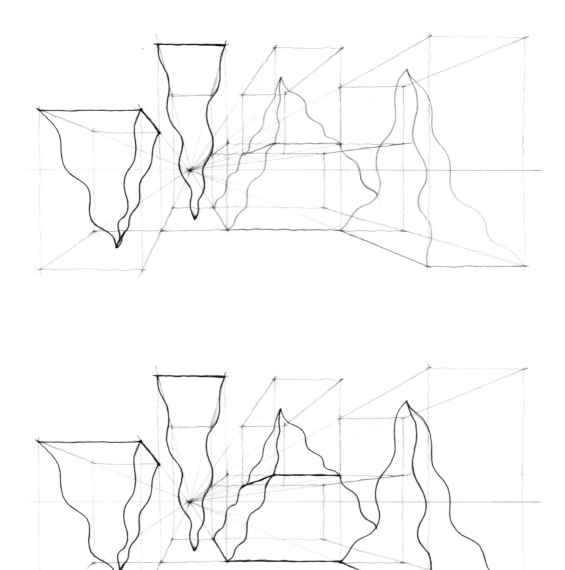

The wireframe of the objects sketched guided by the imaginary boxes.

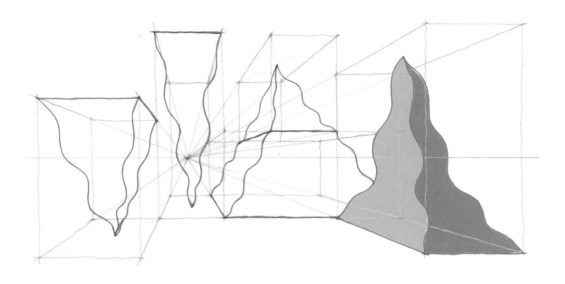

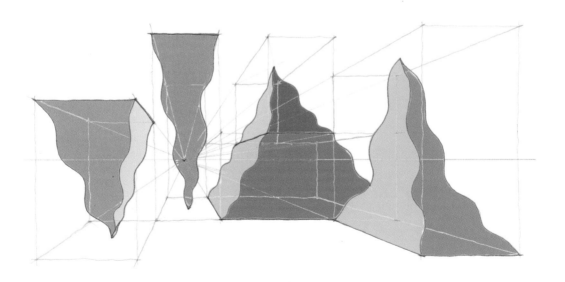

A simple colour rendering to show the formation of the objects surfaces in the composition.

4.1.5 CREATIVE COMPOSITION 05

Many types of surfaces can be created from the imaginary boxes. The 'I.C.E' forms shown below are examples of surfaces that can be sketched using the imaginary boxes as guides. Look carefully at the 'I.C.E' forms. Each of them are sketched using curved lines with different curvatures. It is important to understand the function of each curved line in relation to the forms as the curvatures will influence the quality of the composition.

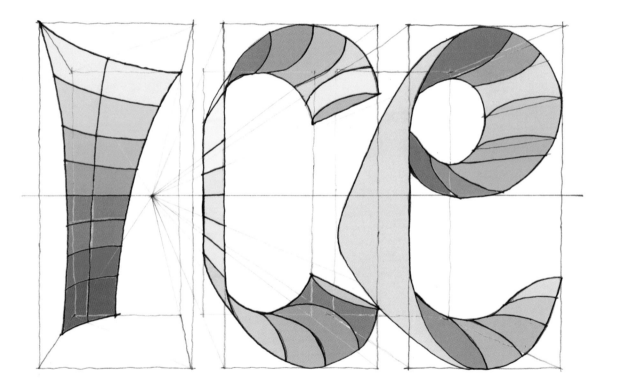

Creative composition 05

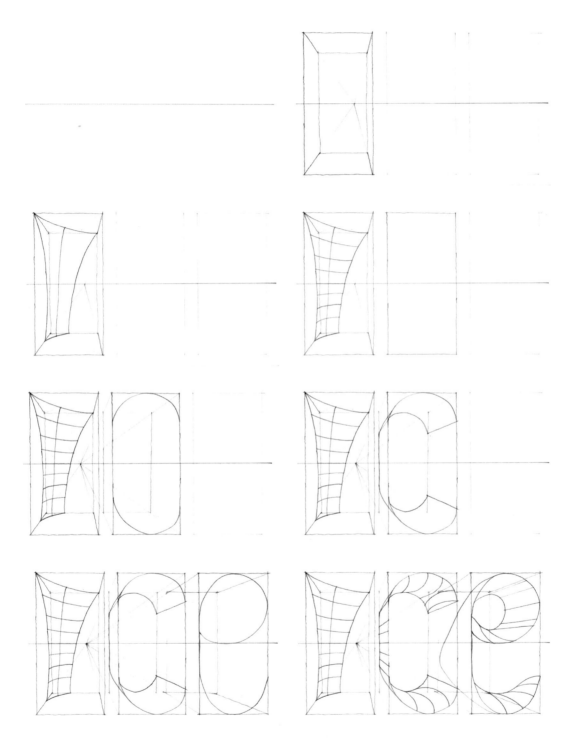

The step by step process of sketching the complex objects composition.

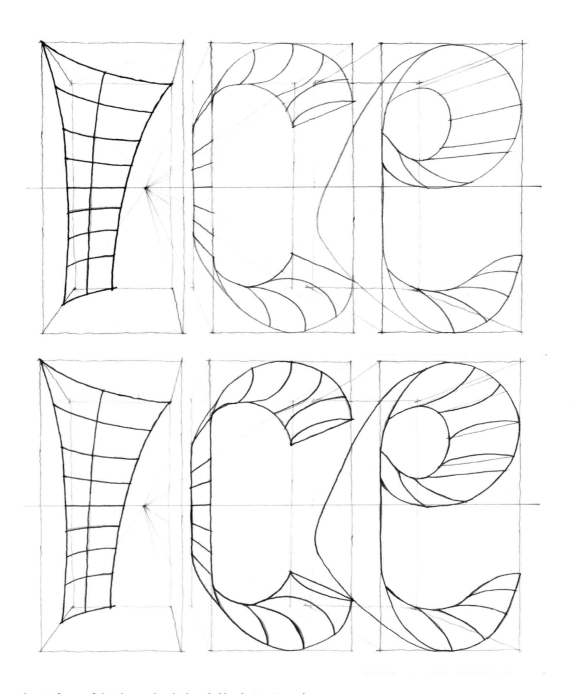

The wireframe of the objects sketched guided by the imaginary boxes.

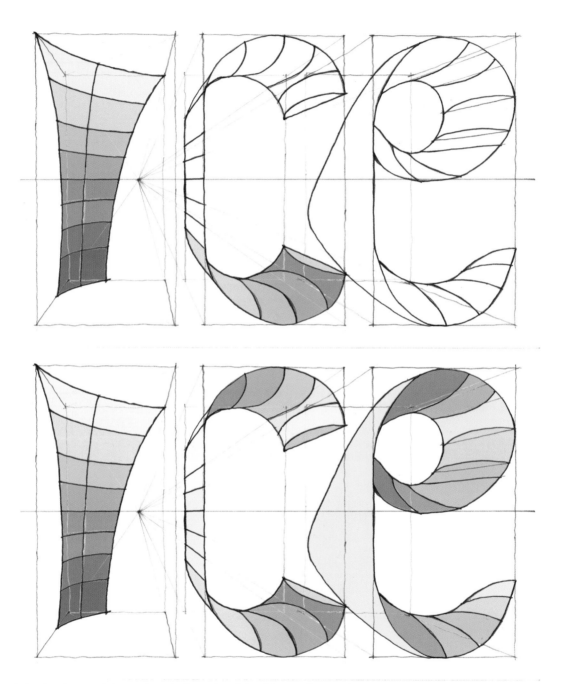

A simple colour rendering to show the formation of the objects surfaces in the composition.

4.1.6 CREATIVE COMPOSITION 06

Sketching alphabets and numbers are intriguing processes to explore. Below are selected letters and numbers that are formed using the imaginary boxes as guides. The sizes of the forms are controlled by the sizes of the imaginary boxes. On the other hand, the horizon line and the vanishing point govern the positions of the letters and numbers.

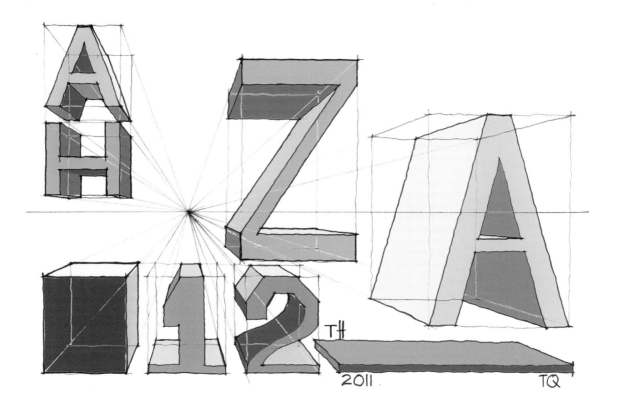

Creative composition 06

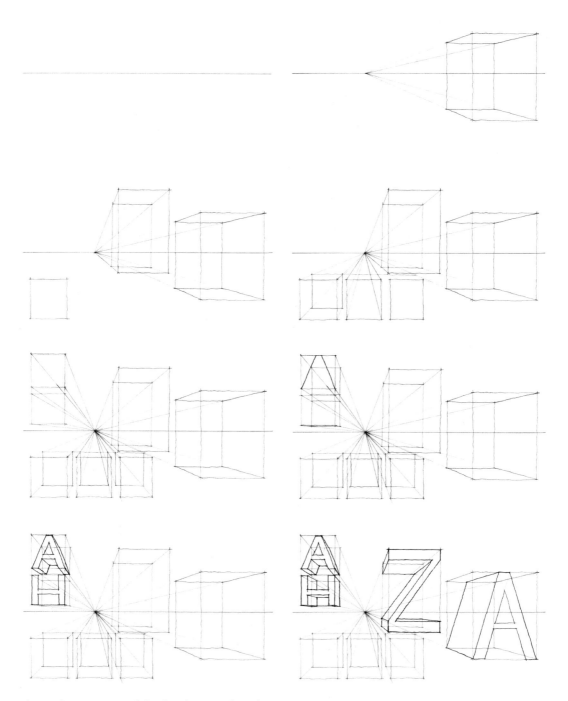

The step by step process of sketching letters and numbers composition.

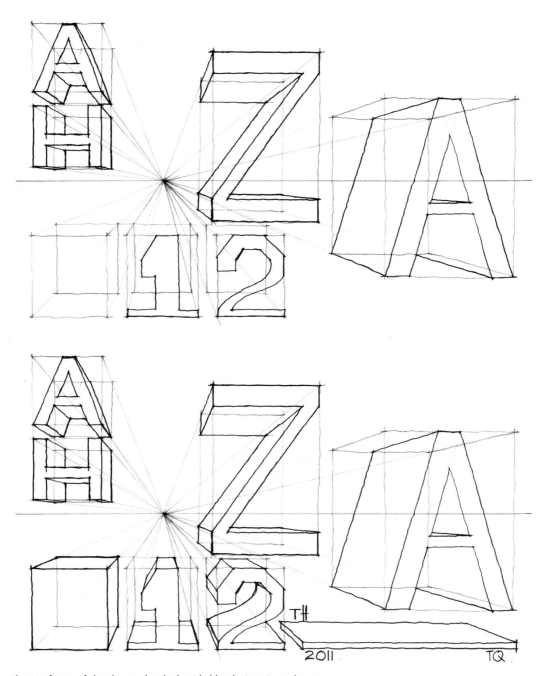

The wireframe of the objects sketched guided by the imaginary boxes.

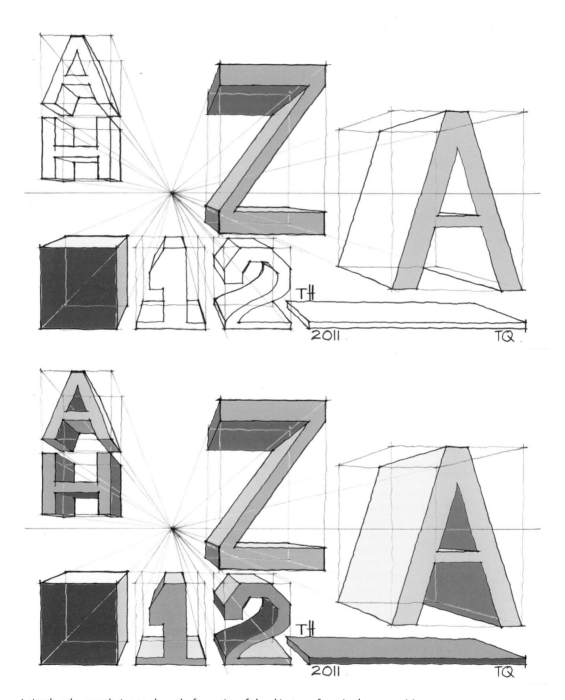

A simple colour rendering to show the formation of the objects surfaces in the composition.

4.1.7 CREATIVE COMPOSITION 07

A combination of forms can create a space or spaces. The example given shows a combination of forms that creates a space between objects. An artist should be able to position each form in the right places in order to create a space. The rectangular box acts as a wall while the arch form acts as an archway. Long, horizontal rectangle boxes are arranged to act as a ceiling for the space below.

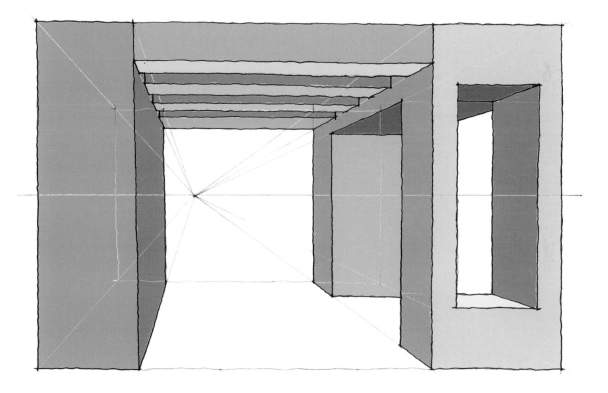

Creative composition 07

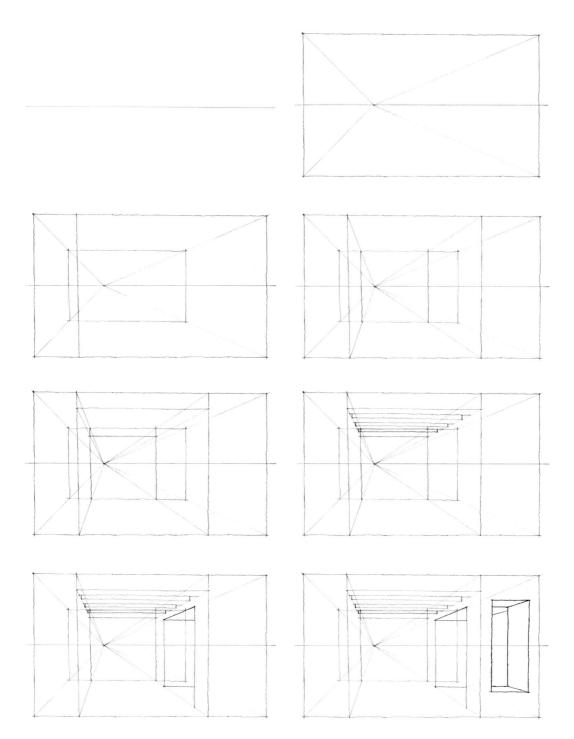

The step by step process of sketching rectangles composition.

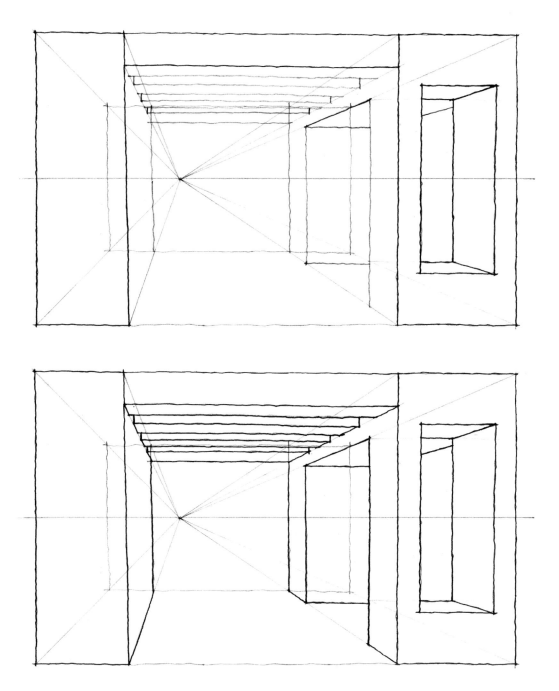

The wireframe of the objects sketched guided by the imaginary boxes.

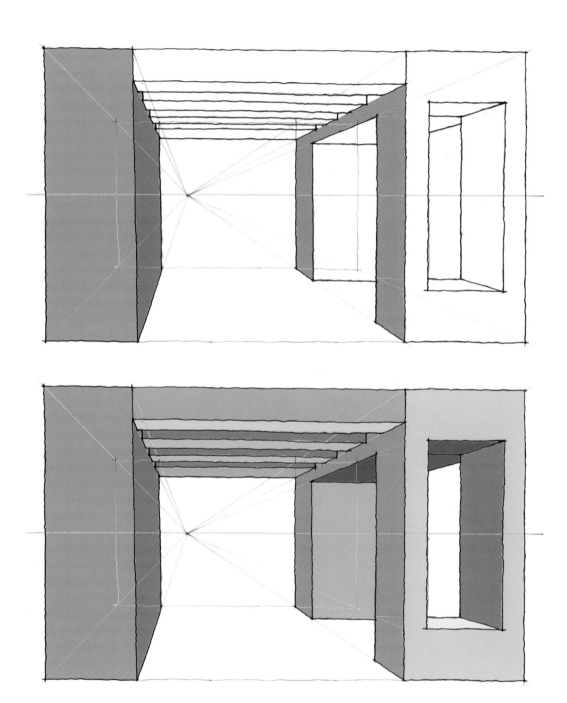

A simple colour rendering to show the formation of the objects surfaces in the composition.

4.1.8 CREATIVE COMPOSITION 08

Many types of compositions can be created from a combination of forms. An example of a composition comprising of multiple forms is shown below. Creativity and curiosity are necessary to compose such an interesting composition. The process of creating this composition begins with a set of imaginary boxes. Then, the objects are sketched one by one in their positions to complete this creative composition.

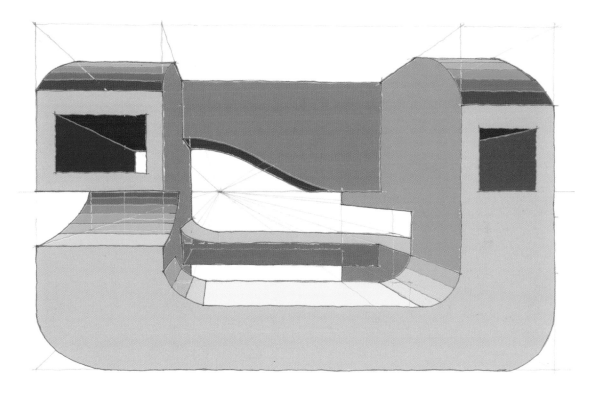

Creative composition 08

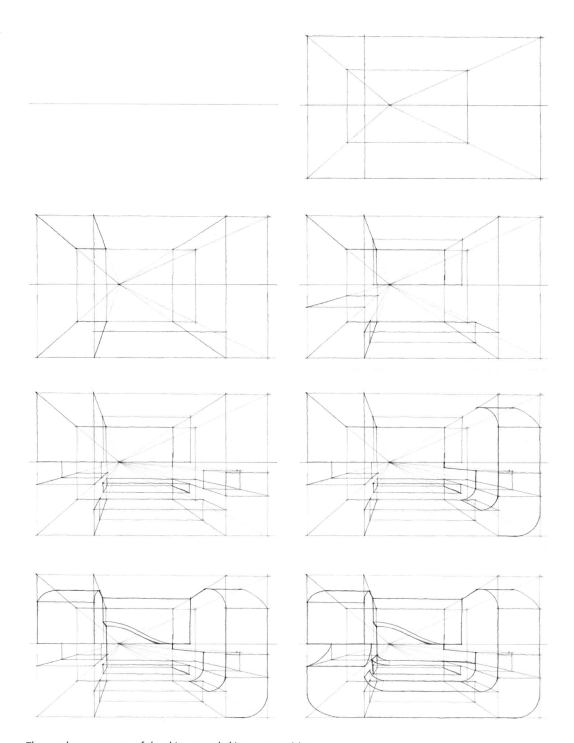

The step by step process of sketching curved objects composition.

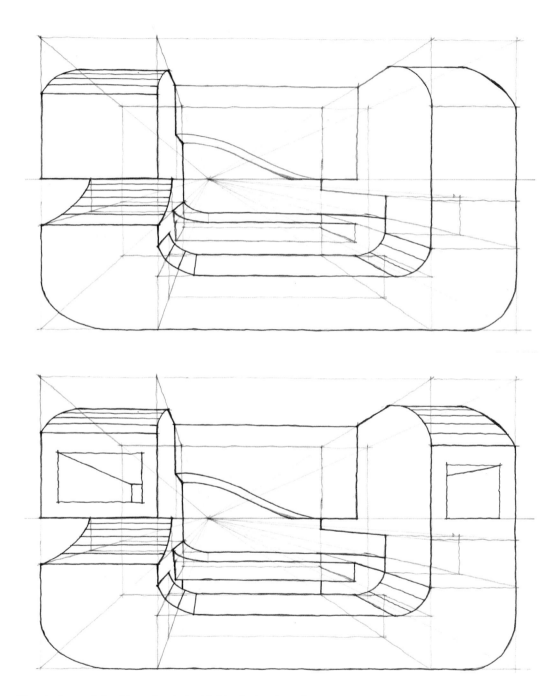

The wireframe of the objects sketched guided by the imaginary boxes.

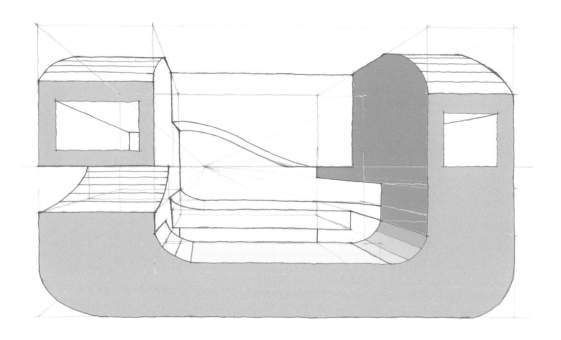

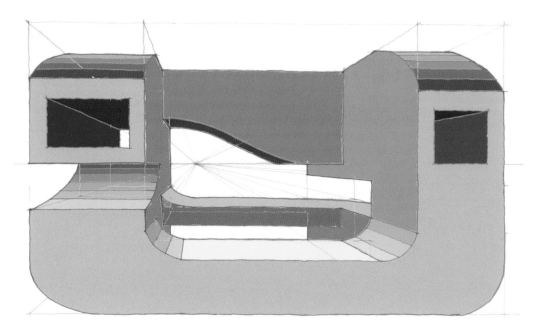

A simple colour rendering to show the formation of the objects surfaces in the composition.

4.1.9 CREATIVE COMPOSITION 09

Sketching triangles in a perspective setting is challenging. But with the guidance of imaginary boxes, this process becomes easier. The process of sketching triangles starts with forming the imaginary boxes. The sizes of the imaginary boxes should reflect the size of the triangles you need. As the examples below demonstrate, you should refer to the imaginary boxes while sketching the triangles.

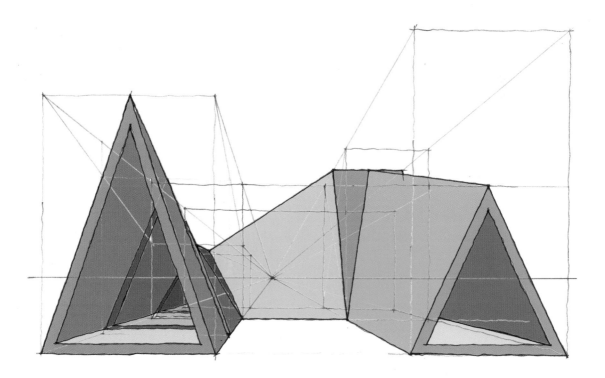

Creative composition 09

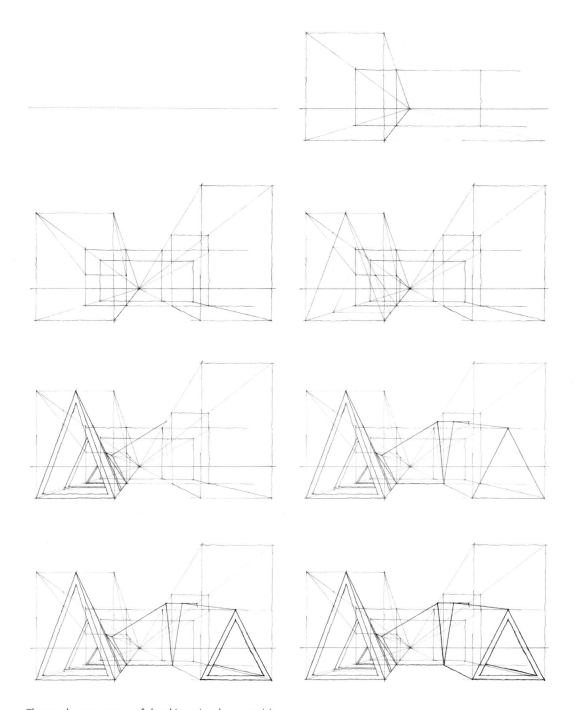

The step by step process of sketching triangle composition.

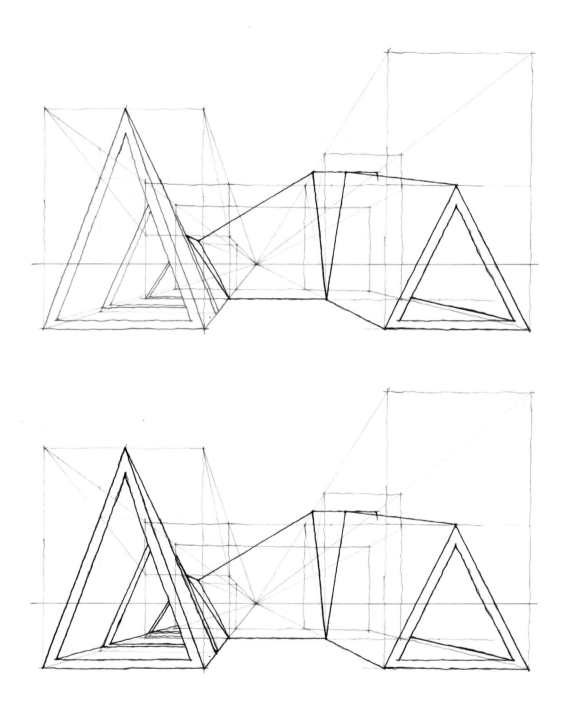

The wireframe of the objects sketched guided by the imaginary boxes.

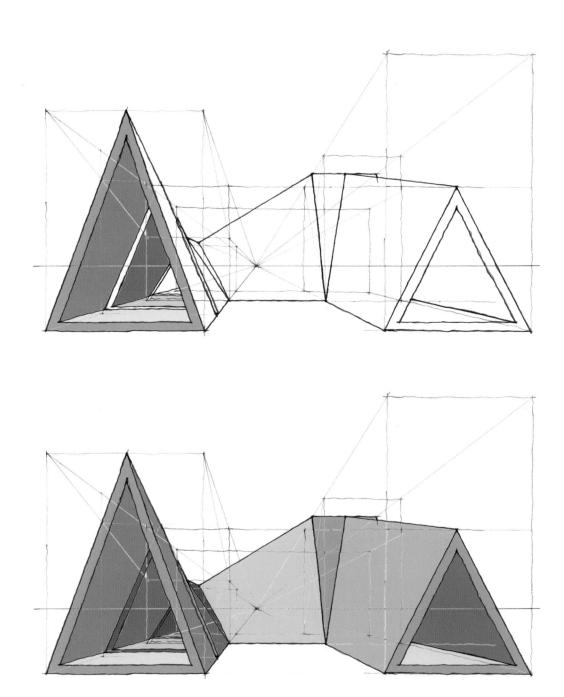

A simple colour rendering to show the formation of the objects surfaces in the composition.

4.1.10 CREATIVE COMPOSITION 10

Sketching creative compositions in a one point perspective setting is all about exploring forms. Many combinations of forms can be created using imaginary boxes as guides. More interesting and unique compositions are made possible by having the ability to visualize creative forms. Observe the examples given. The forms are sketched using the different imaginary boxes as guides, thus making the composition visually interesting.

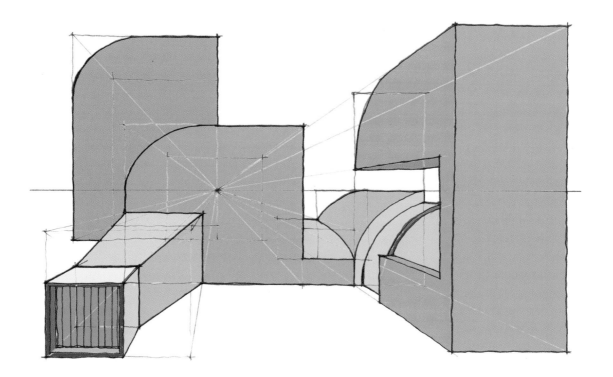

Creative composition 10

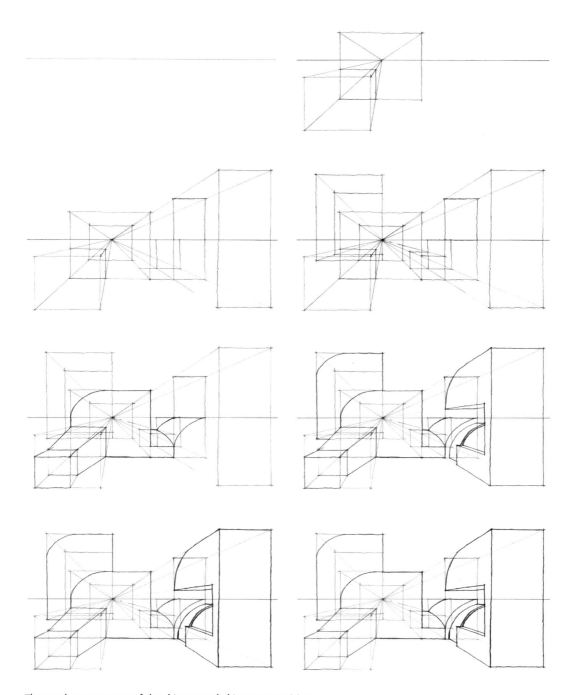

The step by step process of sketching curved objects composition.

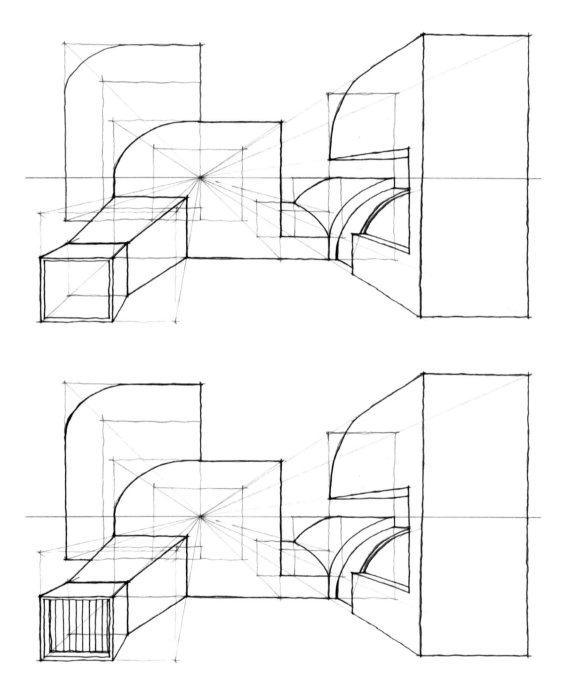

The wireframe of the objects sketched guided by the imaginary boxes.

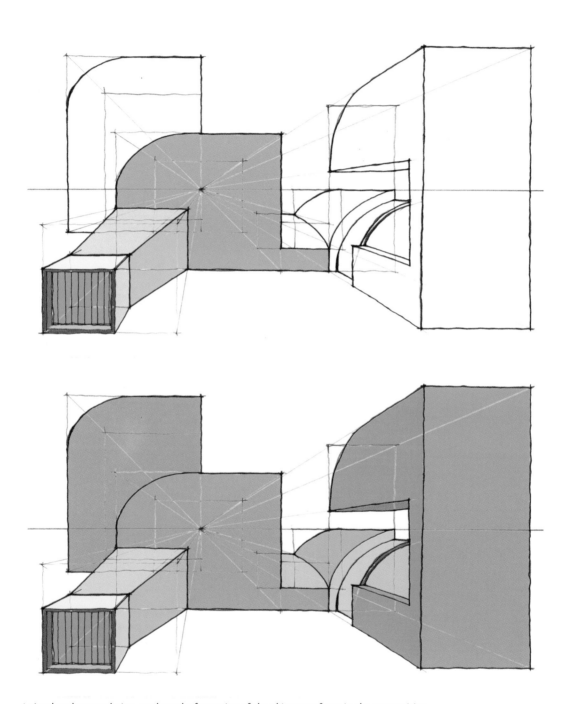

A simple colour rendering to show the formation of the objects surfaces in the composition.

4.1.11 CREATIVE COMPOSITION 11

A combination of basic forms can create a functional creative composition. Take for example a gazebo, as demonstrated below. The pyramid acts as a roof, while the vertical boxes serve as planes supporting the roof. Another horizontal plane acts as a floating platform attached to the vertical plane.

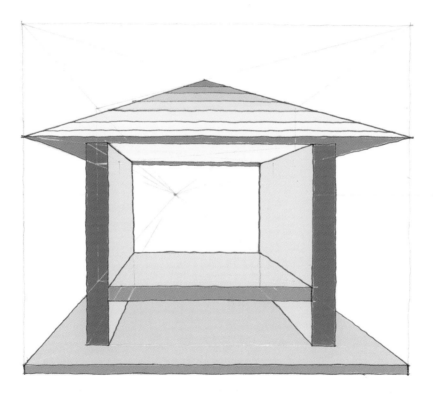

Creative composition 11

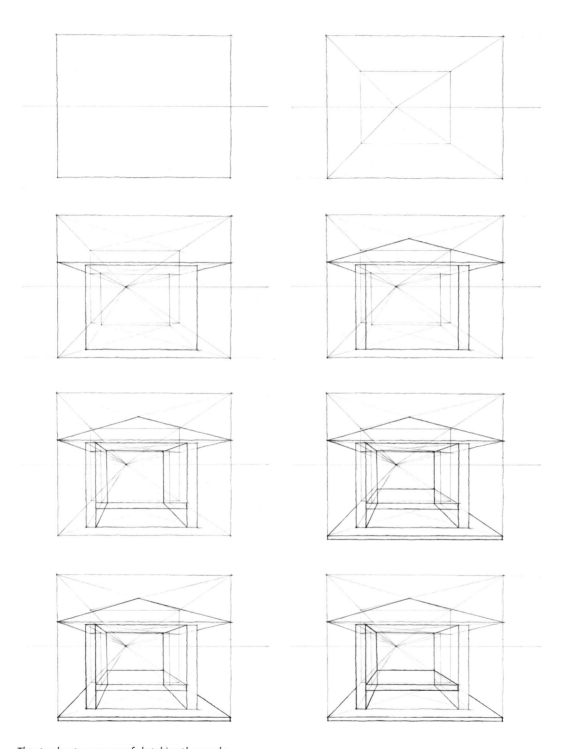

The step by step process of sketching the gazebo.

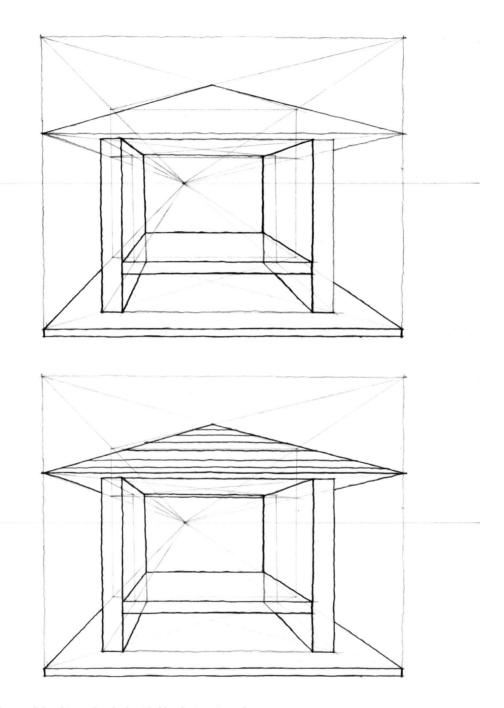

The wireframe of the objects sketched guided by the imaginary boxes.

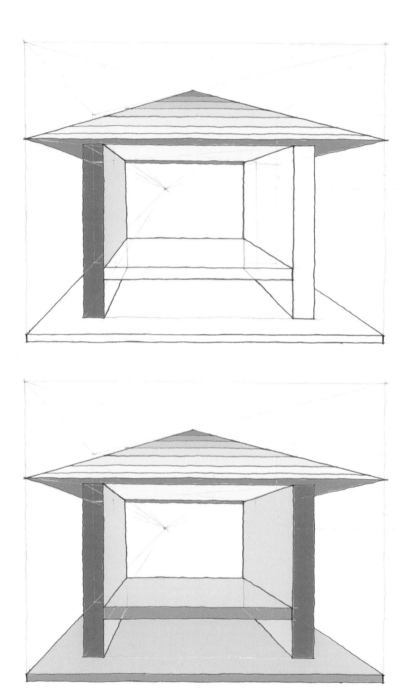

A simple colour rendering as to show the formation of the objects surfaces in the composition.

4.1.12 CREATIVE COMPOSITION 12

This creative composition is about the process of creating a curve effect in the opening of planes. It is important for an artist to master the skilful and creative usage of imaginary boxes. Observe the process of how openings are sketched to create a 'curve' effect. The process starts by sketching the planes. Then, a curved form is embedded in the planes. Finally, the openings are sketched onto the planes, using the frame of the curve as a guide.

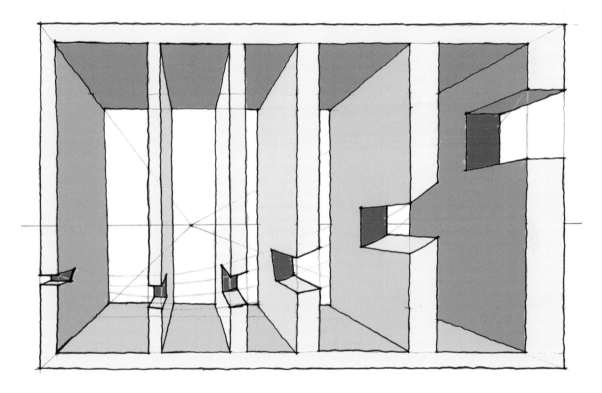

Creative composition 12

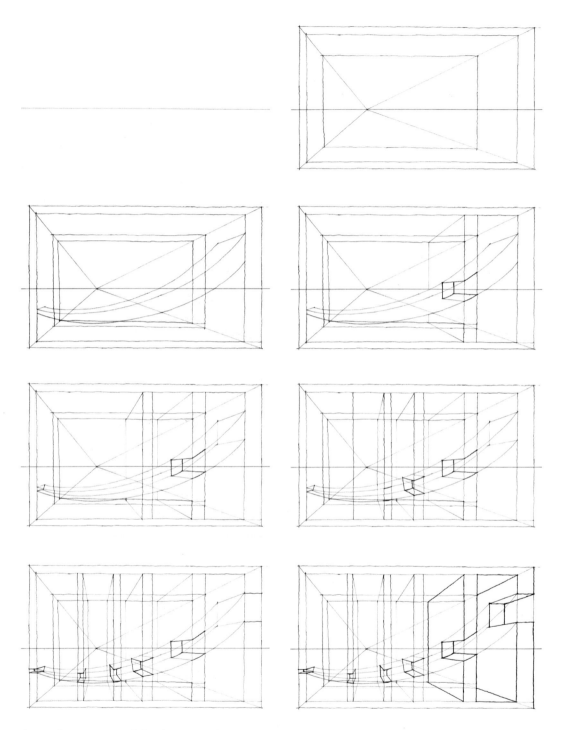

The step by step process of sketching a complex composition.

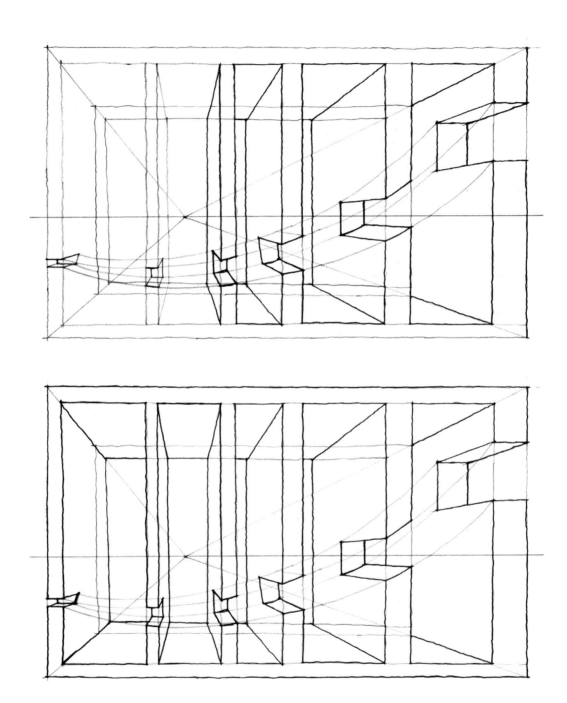

The wireframe of the objects sketched guided by the imaginary boxes.

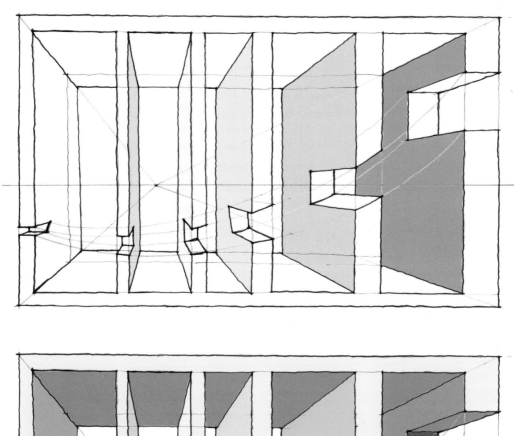

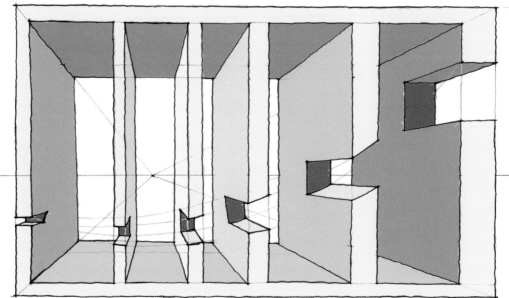

A simple colour rendering as to show the formation of the objects surfaces in the composition.

4.1.13 CREATIVE COMPOSITION 13

This is an interesting composition. The composition is based on a basic object that, in this case, is a rectangular box. The composition's visual dynamics are provided by the position of the boxes. Observe how the boxes are sketched. The process begins with sketching the boxes in a two dimensional setting Then, the lines of the boxes are projected towards the vanishing point to create the depths of these boxes.

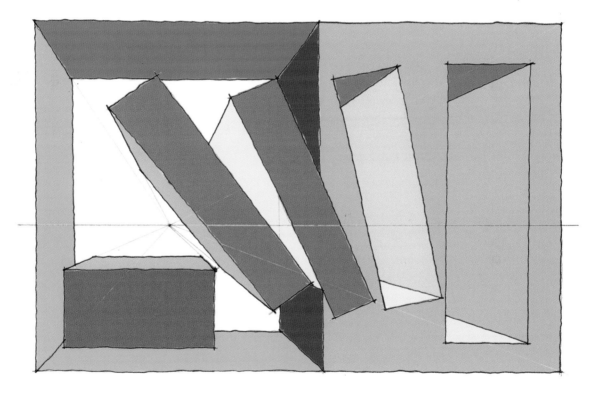

Creative composition 13

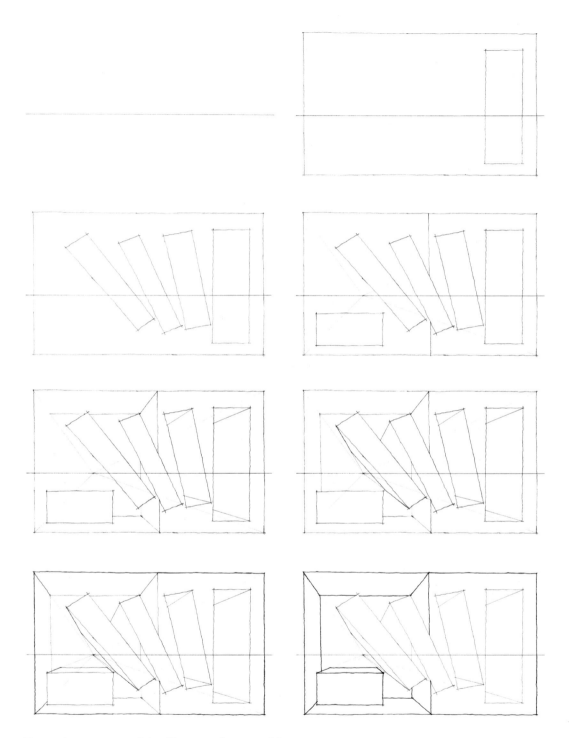

The step by step process of sketching a complex composition.

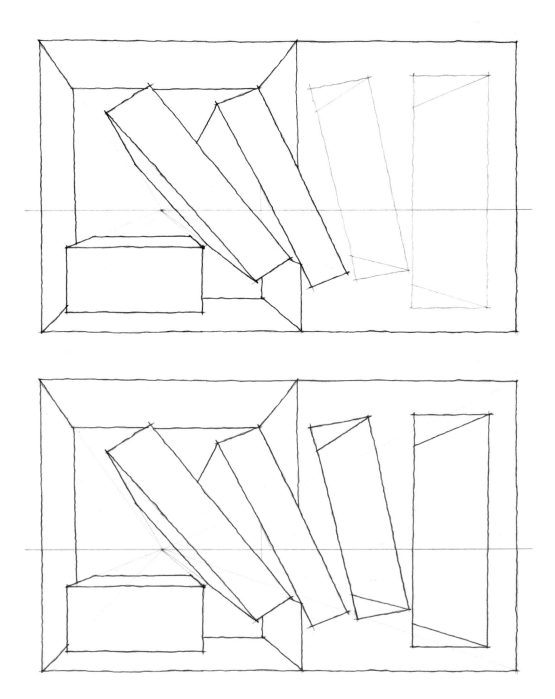

The wireframe of the objects sketched guided by the imaginary boxes.

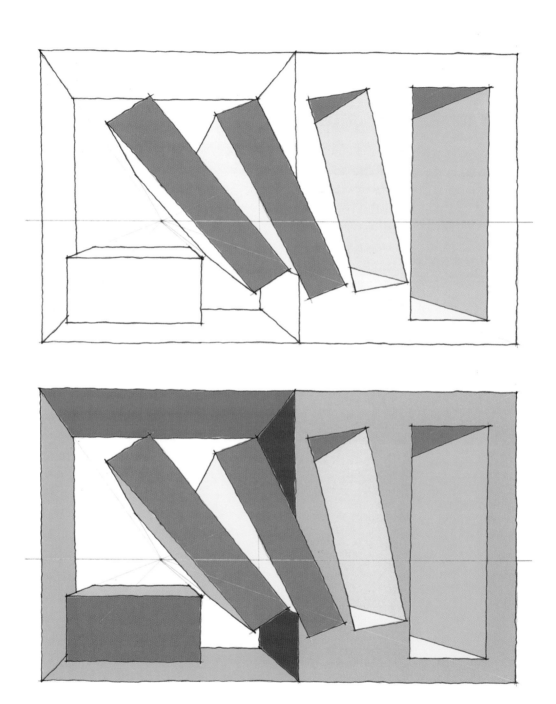

A simple colour rendering as to show the formation of the objects surfaces in the composition.

4.1.14 CREATIVE COMPOSITION 14

This is a unique composition that employs the concept of projection and recession in an imaginary box setting. Here are three examples of forms that are sketched using this concept. The ability to transform a basic, simple box into a more complex box composition is an avenue for an artist to explore the creation of more interesting forms. The key is to master sketching and to have a good knowledge of a one point perspective setting.

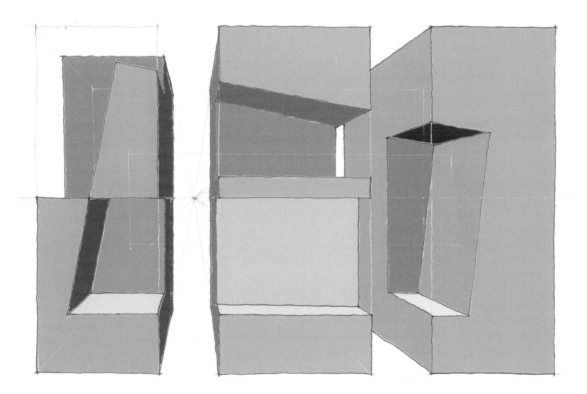

Creative composition 14

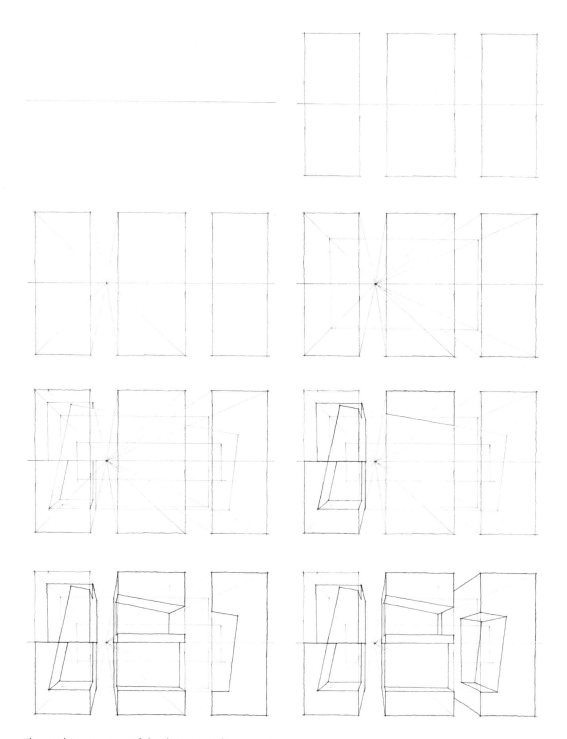

The step by step process of sketching a complex composition.

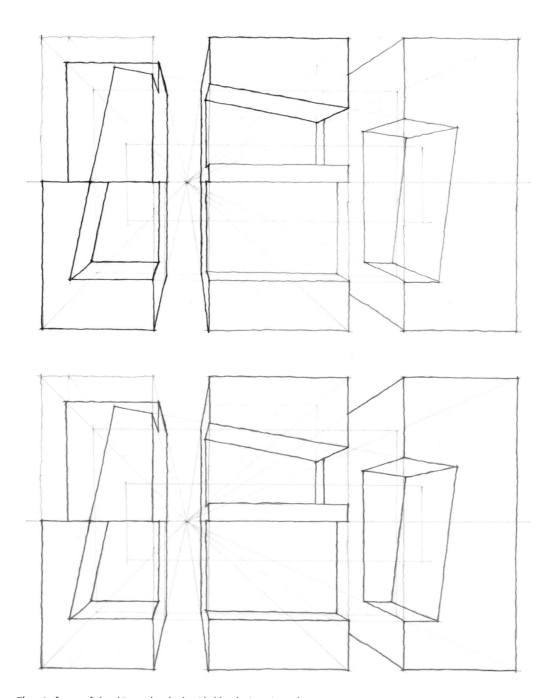

The wireframe of the objects sketched guided by the imaginary boxes.

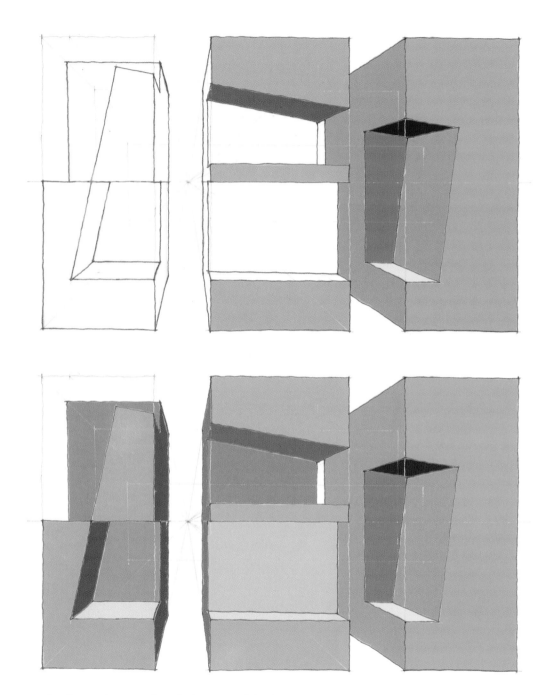

A simple colour rendering to show the formation of the objects surfaces in the composition.

4.1.15 CREATIVE COMPOSITION 15

Creative compositions can be derived from a simple objects com-
position. The horizon line and vanishing point play very important
roles in creating this interesting composition. To produce an excel-
lent visual outcome, an artist must be able to decide the right posi-
tions for the horizon line and vanishing point.

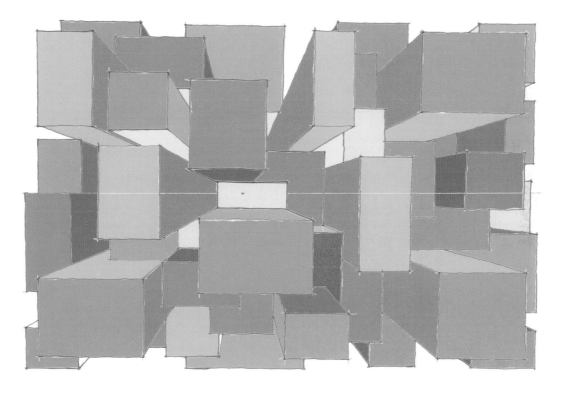

Creative composition 15

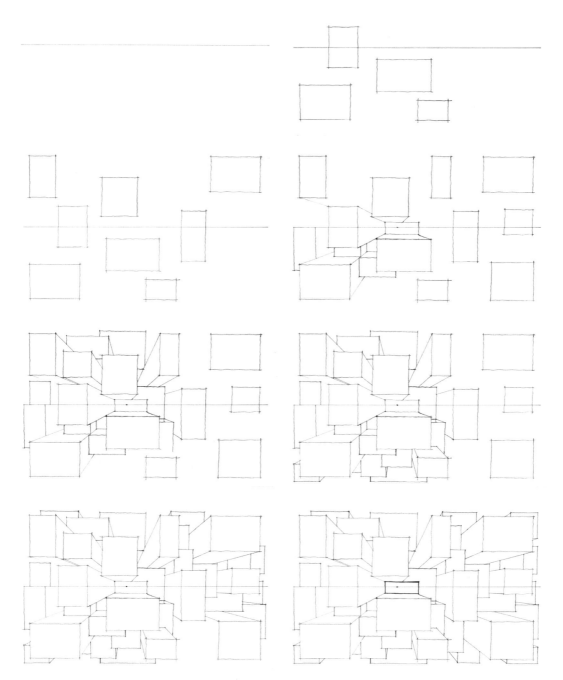

The step by step process of sketching a complex composition.

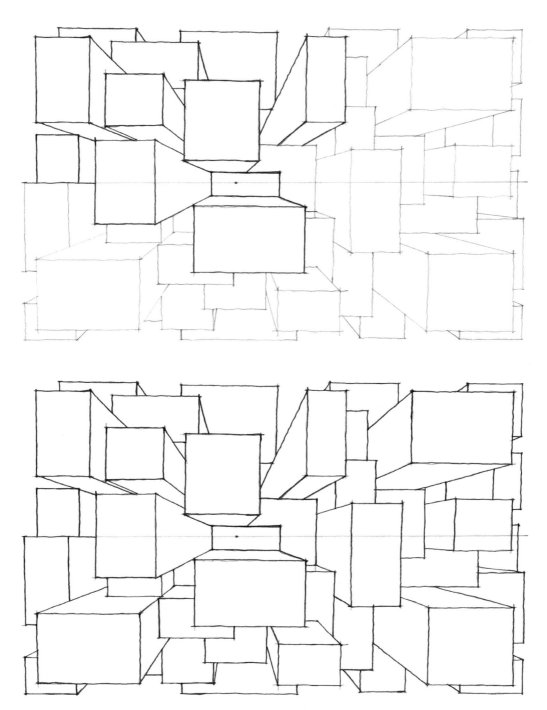

The wireframe of the objects sketched guided by the imaginary boxes.

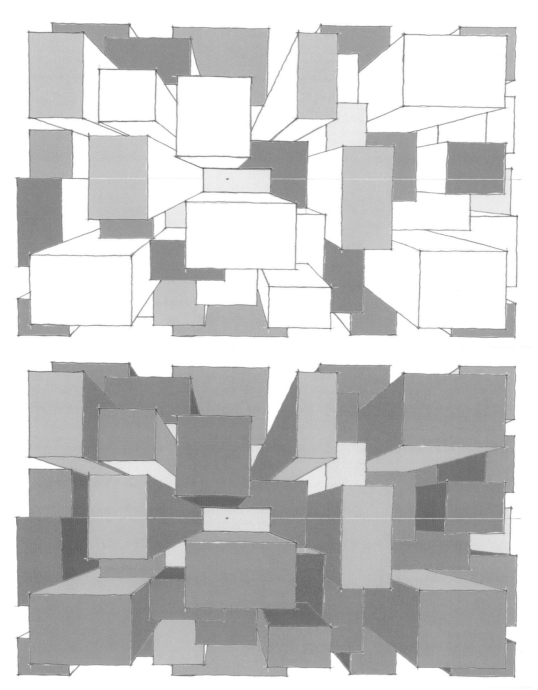

A simple colour rendering to show the formation of the objects surfaces in the composition.

4.1.16 CREATIVE COMPOSITION 16

The triangle is an interesting form. A proper arrangement of varying forms of trianges can result in a creative composition. To give a good visual impact to the composition, an artist must be able to sketch this composition at a proper view angle. Correct view angles can be produced by mastering the skill of positioning the horizon line and vanishing point in a one point perspective setting.

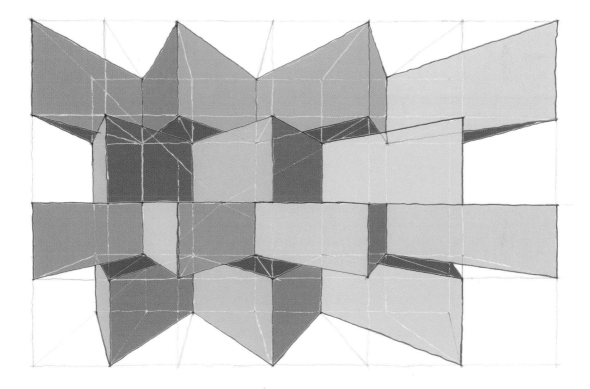

Creative composition 16

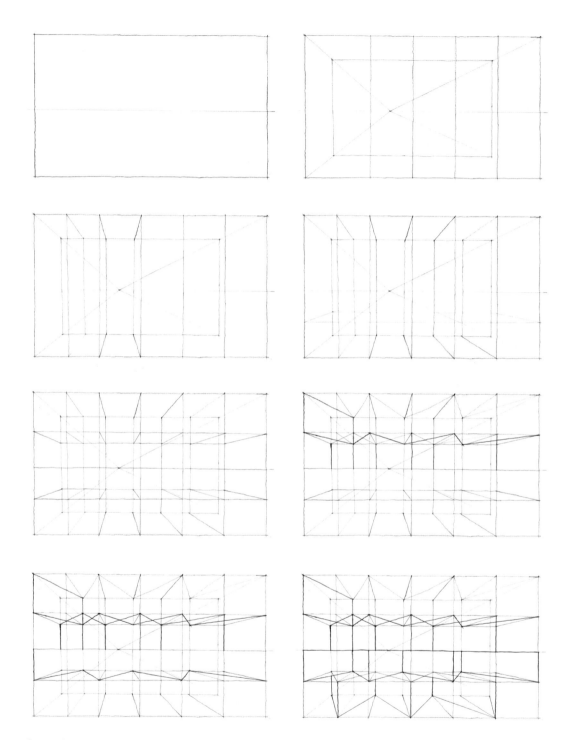

The step by step process of sketching a complex composition.

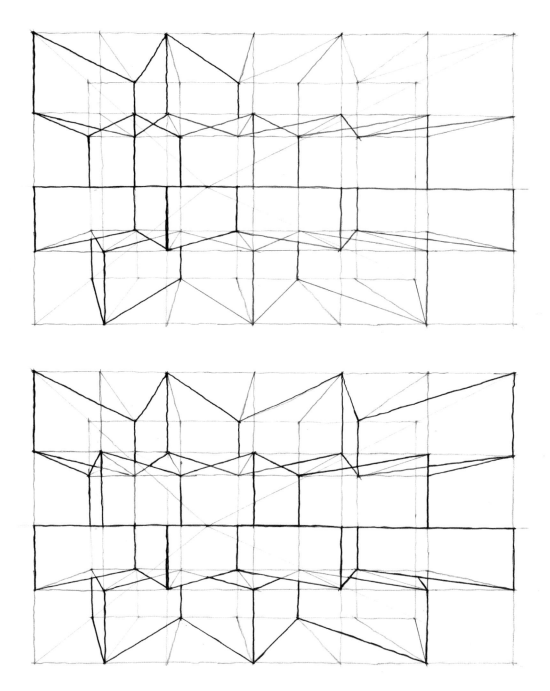

The wireframe of the objects sketched guided by the imaginary boxes.

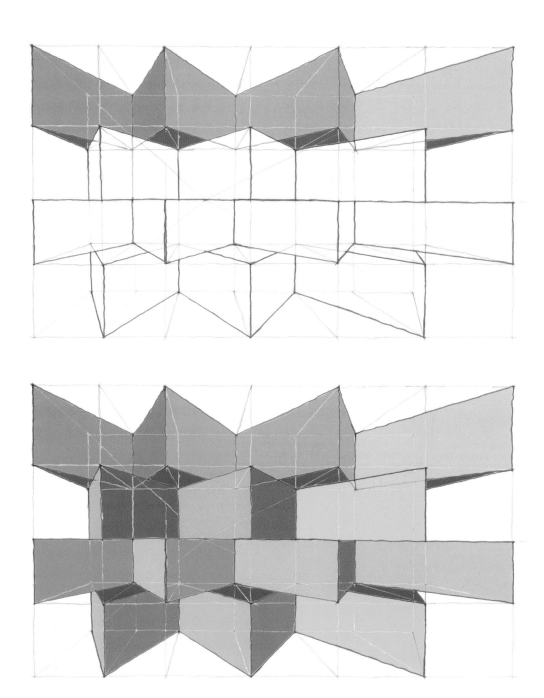

A simple colour rendering to show the formation of the objects surfaces in the composition.

4.1.17 CREATIVE COMPOSITION 17

This creative composition is produced using an imaginary box. The process starts by sketching the imaginary box. Then, the box is divided into a few sections. Next, each line is projected to its proper position. The imaginary boxes guide every line that is sketched.

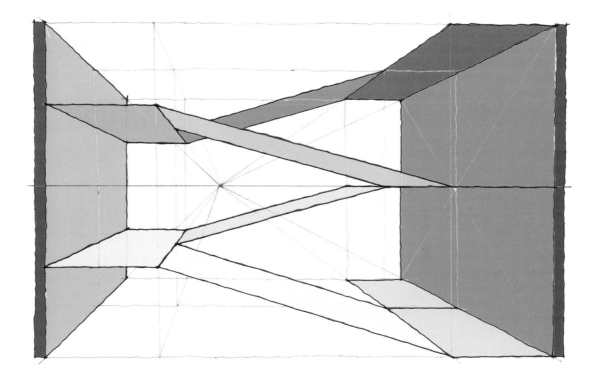

Creative composition 17

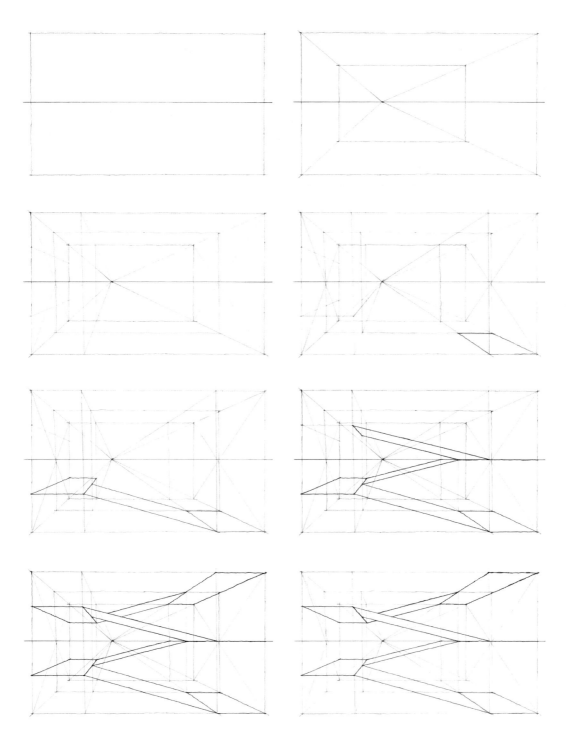

The step by step process of sketching ramps composition.

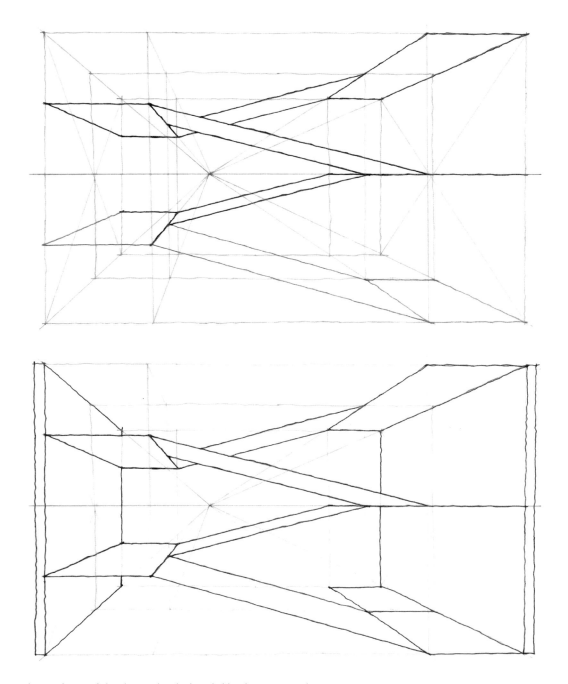

The wireframe of the objects sketched guided by the imaginary boxes.

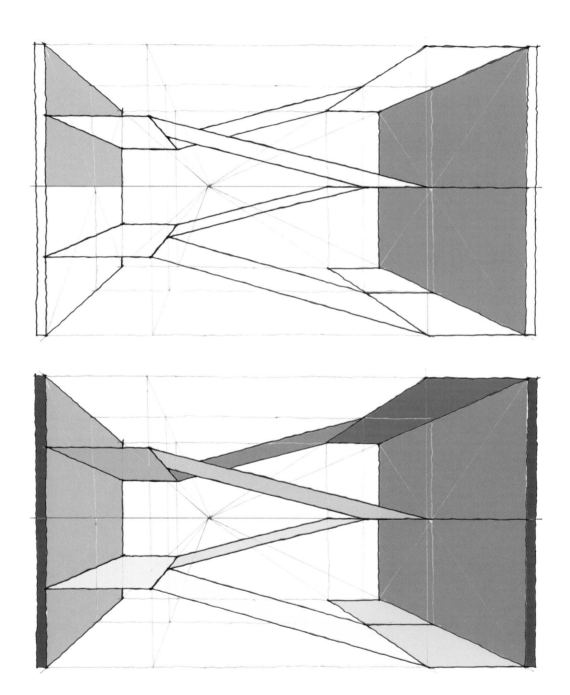

A simple colour rendering to show the formation of the objects surfaces in the composition.

4.1.18 CREATIVE COMPOSITION 18

A combination of ramps creates an interesting creative composition. The ramps are setched using the imaginary boxes as guides. The process starts with setting up the imaginary boxes and continues with the platforms and ramps. To create an interesting composition, an artist must plan the layout of the ramps before sketching them.

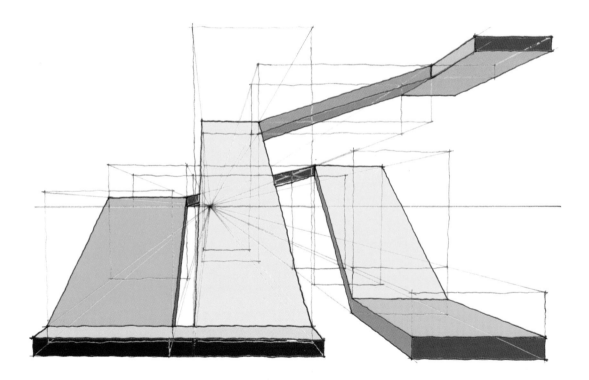

Creative composition 18

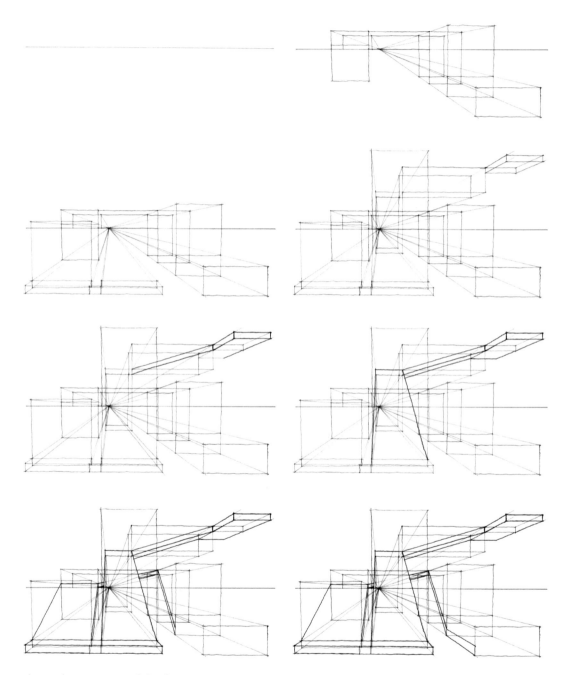

The step by step process of sketching ramps composition.

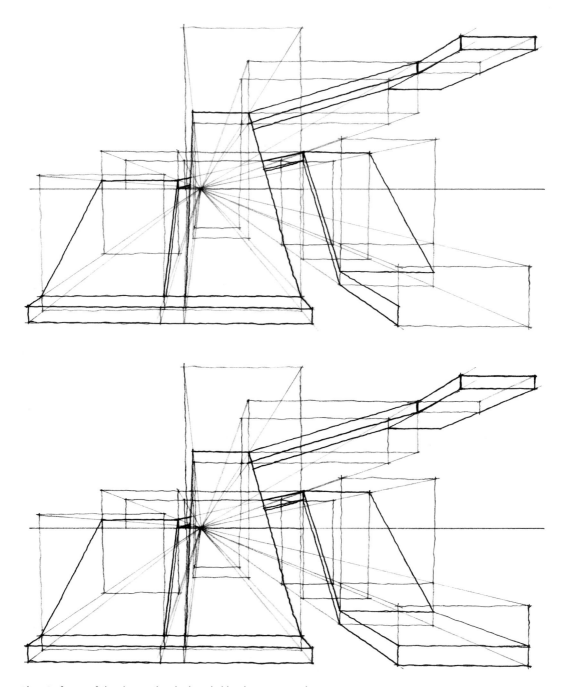

The wireframe of the objects sketched guided by the imaginary boxes.

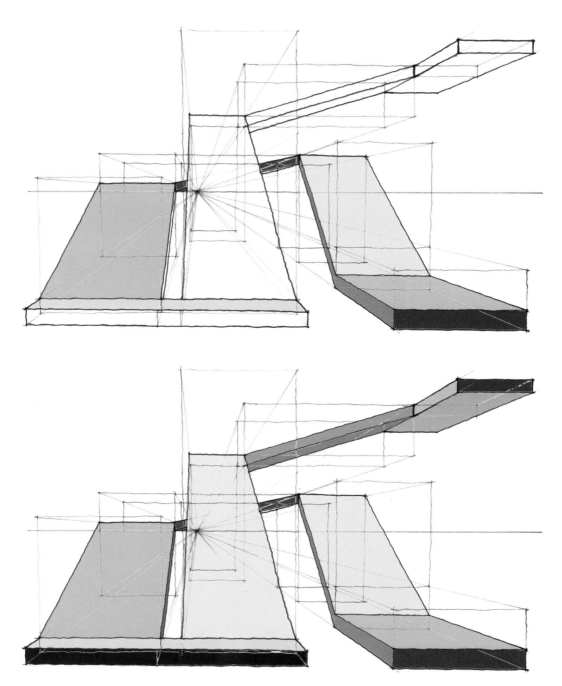

A simple colour rendering to show the formation of the objects surfaces in the composition.

4.1.19 CREATIVE COMPOSITION 19

This is an imaginary structure of ramps connected to each other. This example shows the function of the imaginary box in any creative idea. Many interesting and creative compositions can be sketched using the imaginary boxes as guides. Observe the process of sketching these ramps and planes. This is achieved by dividing the main imaginary box into separate compartments.

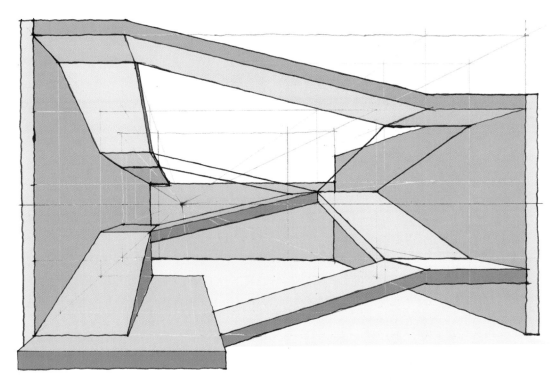

Creative composition 19

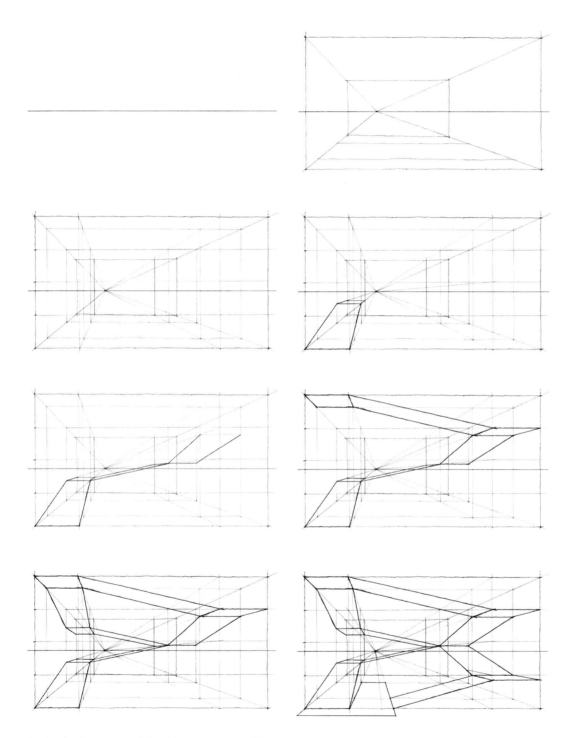

The step by step process of sketching ramps composition.

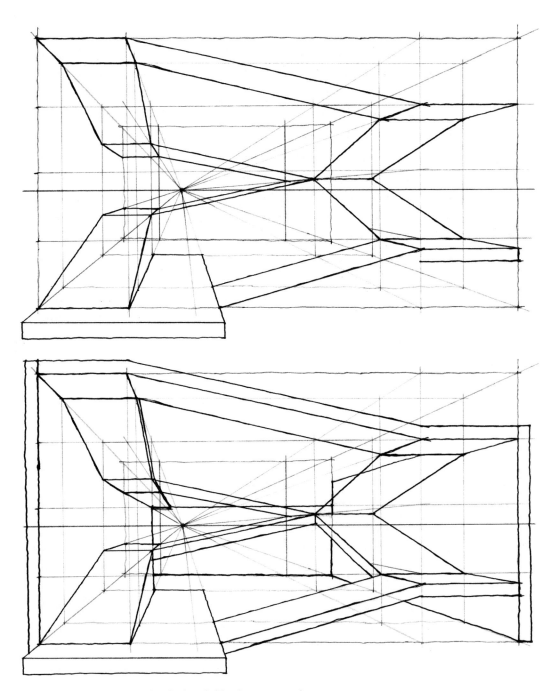

The wireframe of the objects sketched guided by the imaginary boxes.

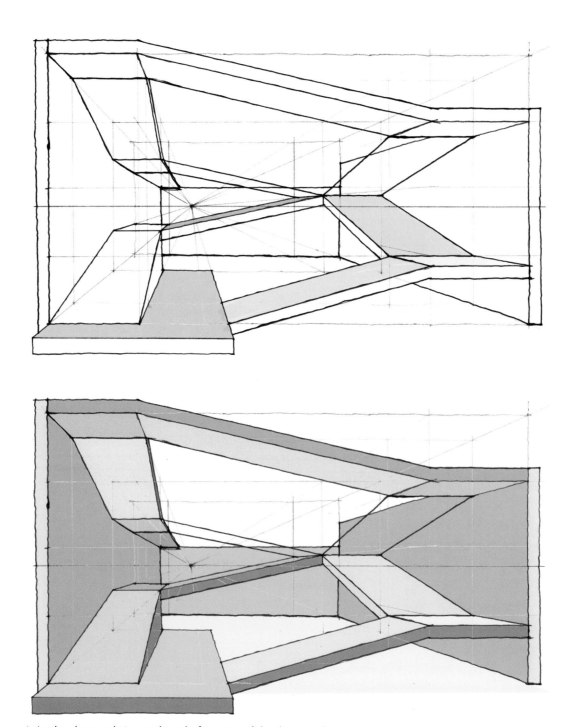

A simple colour rendering to show the formation of the objects surfaces in the composition.

4.1.20 CREATIVE COMPOSITION 20

This composition is produced by a combination of two main forms: rectangular boxes and ramps. These two forms are created using sets of imaginary boxes as guides. Observe the process of sketching this composition. It starts with an imaginary box and continues with other boxes. It is important for an artist to visualize the composition before transferring the mental image of the composition onto a drawing surface.

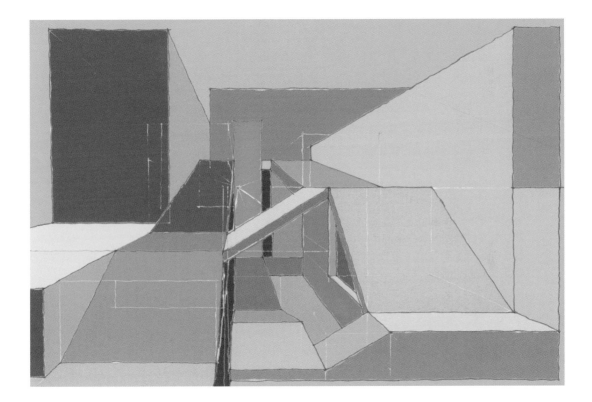

Creative composition 20

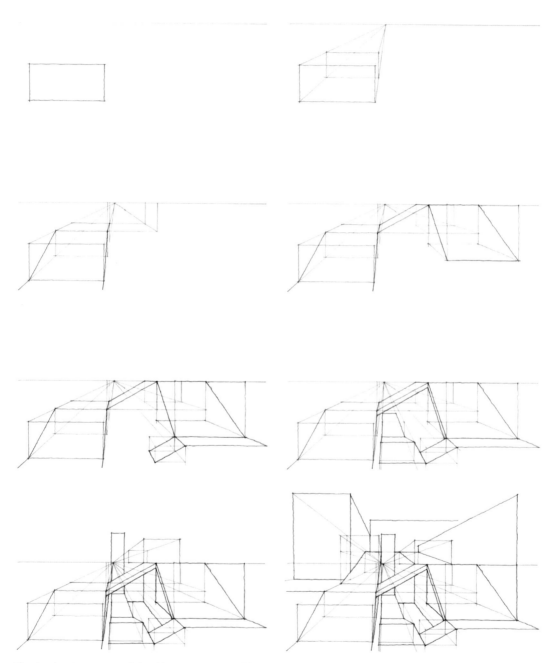

The step by step process of sketching ramps composition.

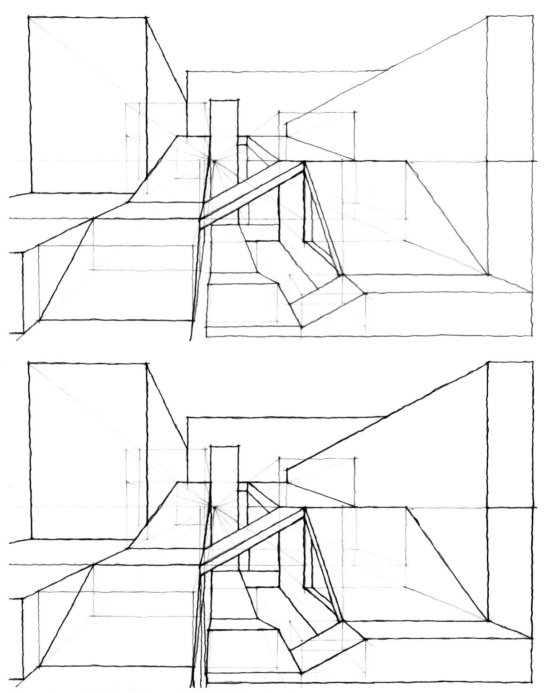

The wireframe of the objects sketched guided by the imaginary boxes.

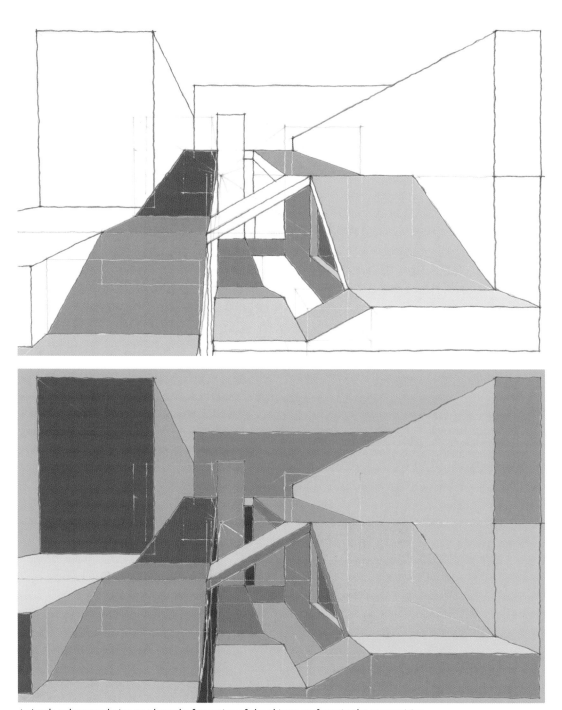

A simple colour rendering to show the formation of the objects surfaces in the composition.

4.1.21 CREATIVE COMPOSITION 21

It is interesting to explore how interesting compositions can be generated with the assistance of imaginary boxes. Observe each step of the process shown here. You start with an imaginary box at one end of the horizon line. Then, you continue with other boxes that are in different positions but remain guided by the vanishing point.

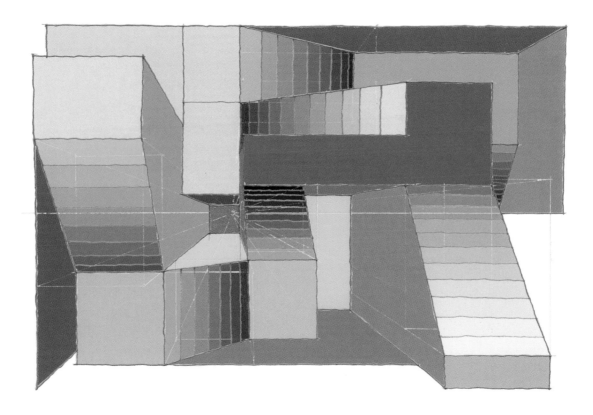

Creative composition 21

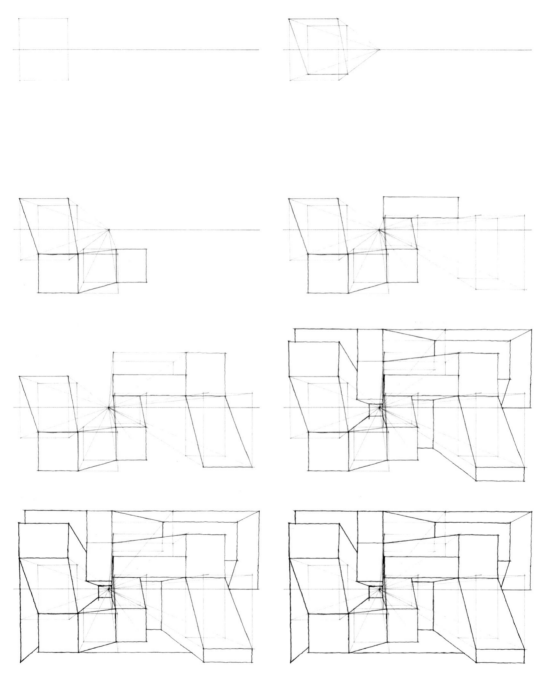

The step by step process of sketching ramps composition.

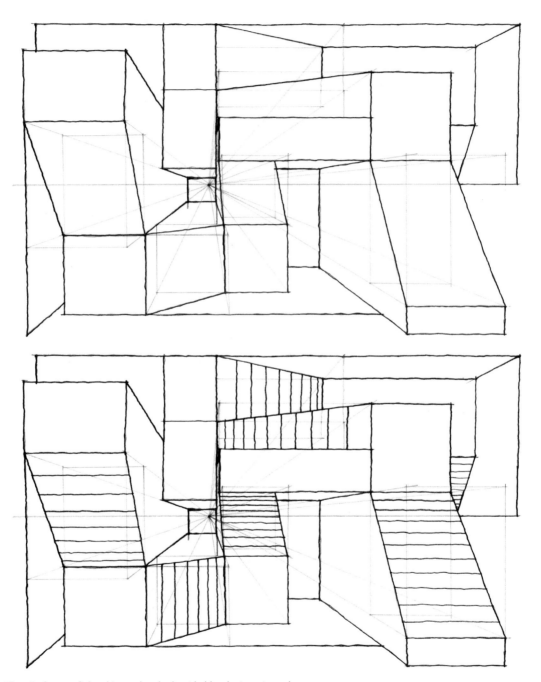

The wireframe of the objects sketched guided by the imaginary boxes.

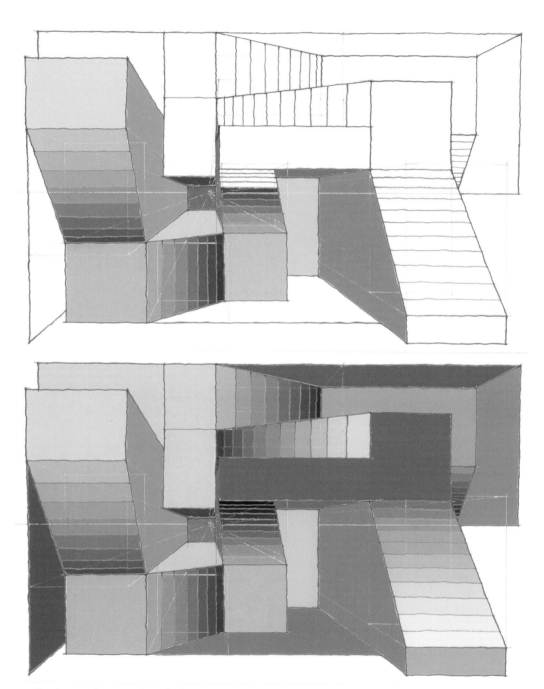

A simple colour rendering to show the formation of the objects surfaces in the composition.

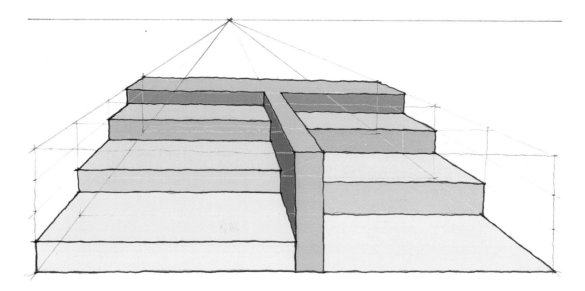

Creative composition 22

4.1.22 CREATIVE COMPOSITION 22

Sketching a stairway using an imaginary box is an intriguing process. As demonstrated by the examples here, many types of stairways can be sketched using the concept of an imaginary box. The surfaces of the risers and treads are sketched using the imaginary boxes as guides. There are two different types of risers and treads sketched using the same process. Hence, there are two varieties of stairways that are sketched using the imaginary box.

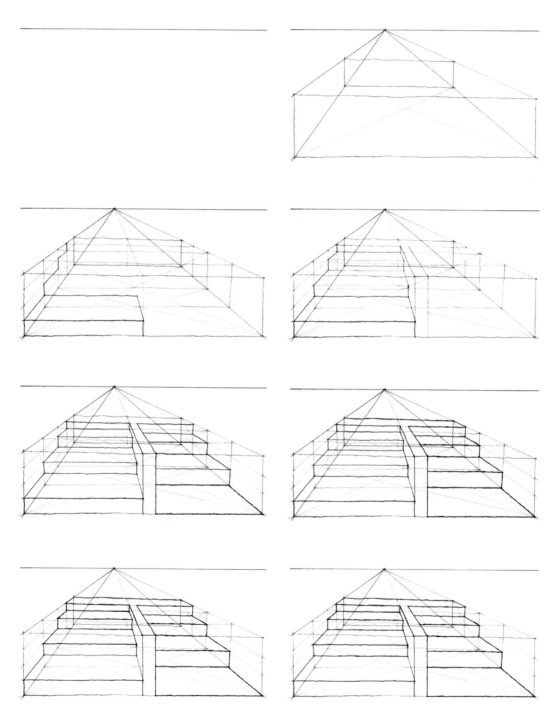

The step by step process of sketching the steps composition.

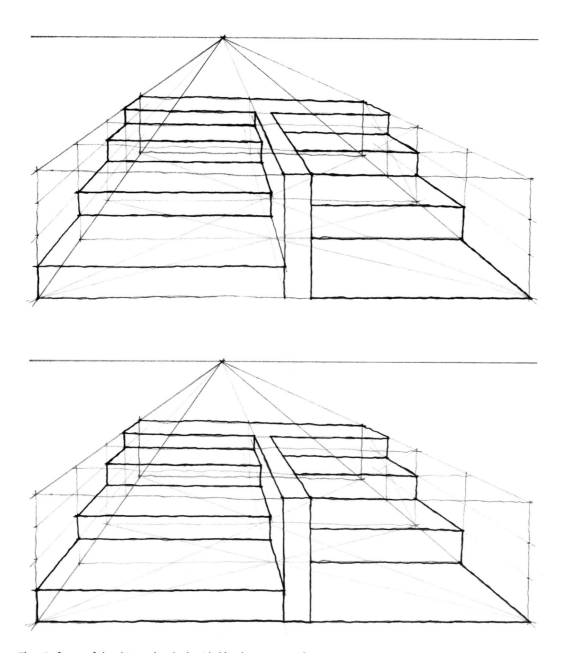

The wireframe of the objects sketched guided by the imaginary boxes.

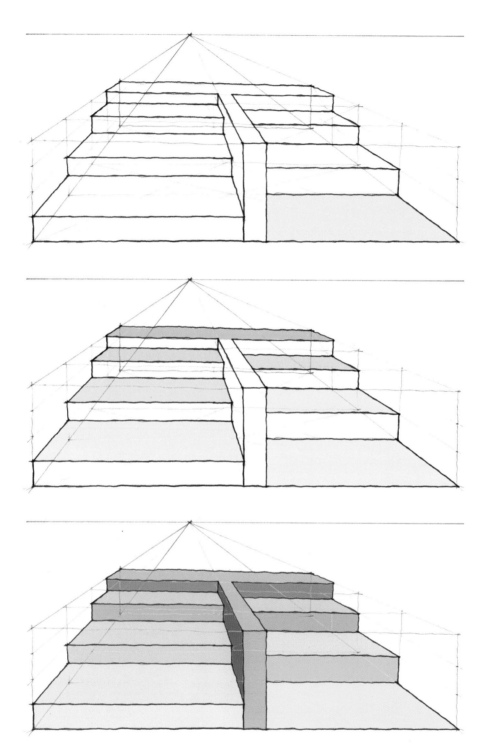

A simple colour rendering to show the formation of the objects surfaces in the composition.

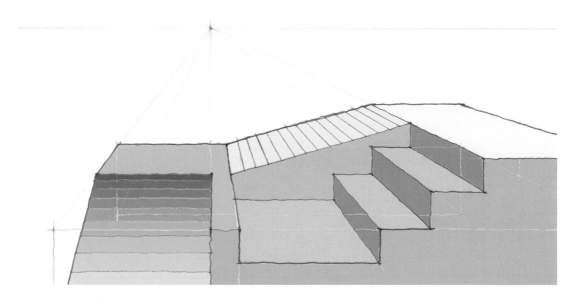

Creative composition 23

4.1.23 CREATIVE COMPOSITION 23

Sketching stairways and ramps is a good exercise to test your understanding of how levels can change in a one point perspective setting. In the example here, the composition is sketched using an imaginary box as a guide. The imaginary box is divided into sections for the risers and treads of the stairway. Similarly, an imaginary box guides the composition of ramps. Then, lines are drawn one by one to finish the overall composition.

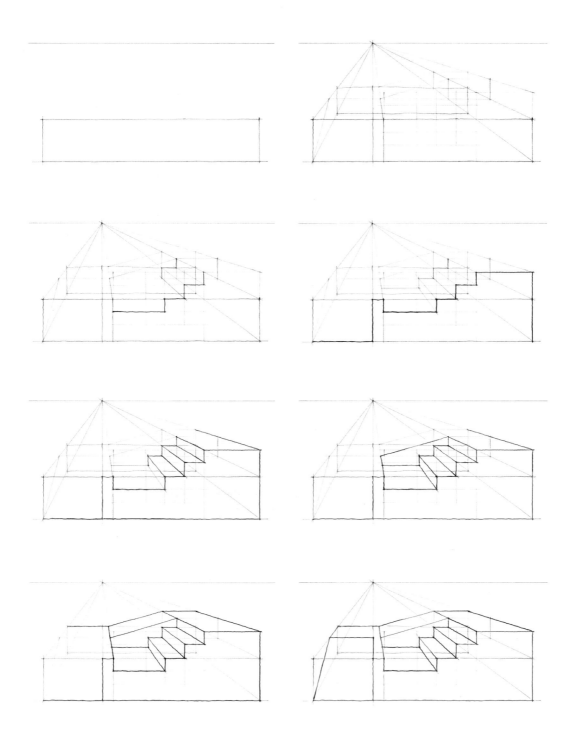

The step by step process of sketching the steps and ramps composition.

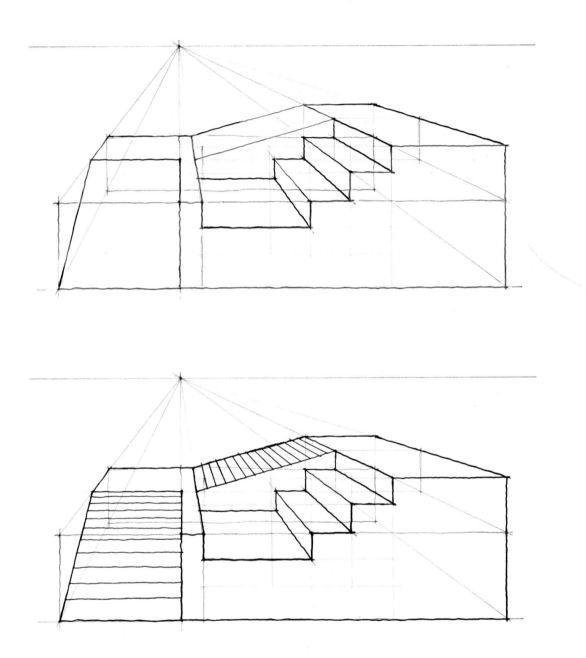

The wireframe of the objects sketched guided by the imaginary boxes.

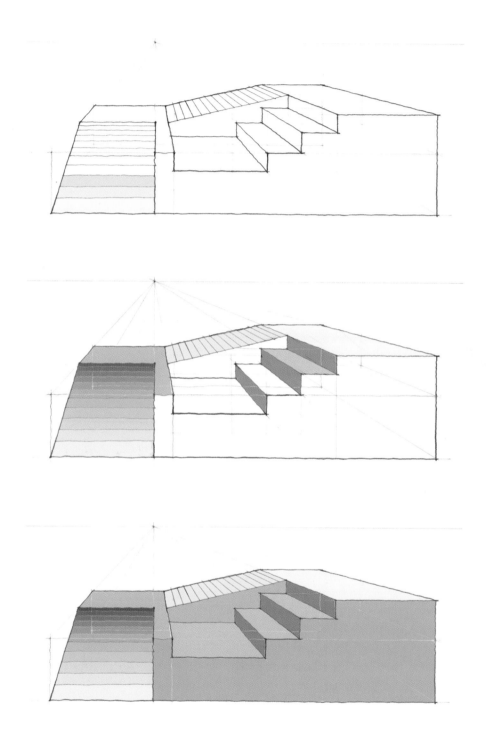

A simple colour rendering to show the formation of the objects surfaces in the composition.

4.1.24 CREATIVE COMPOSITION 24

This space-like is puzzle is a fascinating composition to sketch. The composition is based on four segmented spaces in an imaginary box. The box plays a very important role in defining and guiding the process of sketching the composition. It is up to the artist to decide where to begin sketching the composition. Here, much creativity is required in transforming a simple arrangement of forms into a complex creative composition.

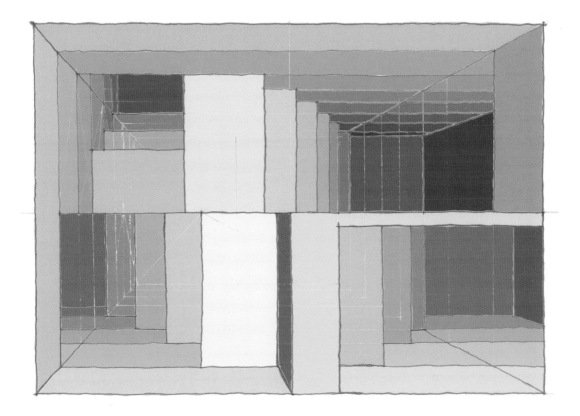

Creative composition 24

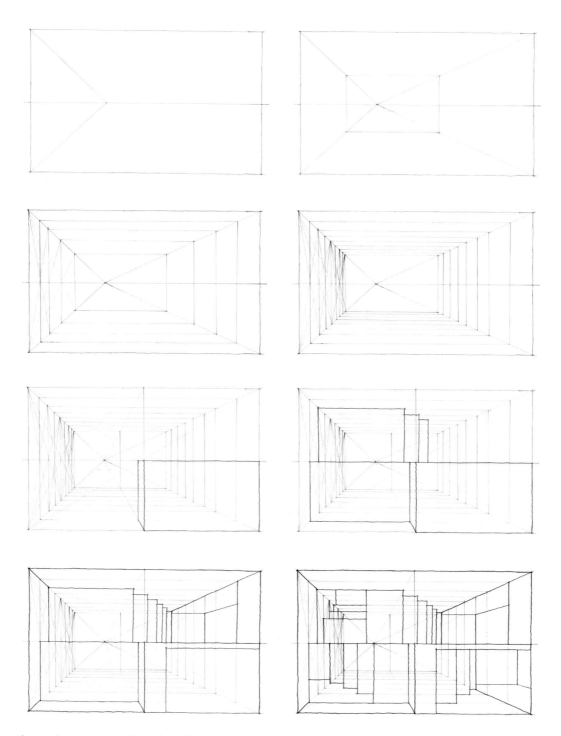

The step by step process of sketching the spaces.

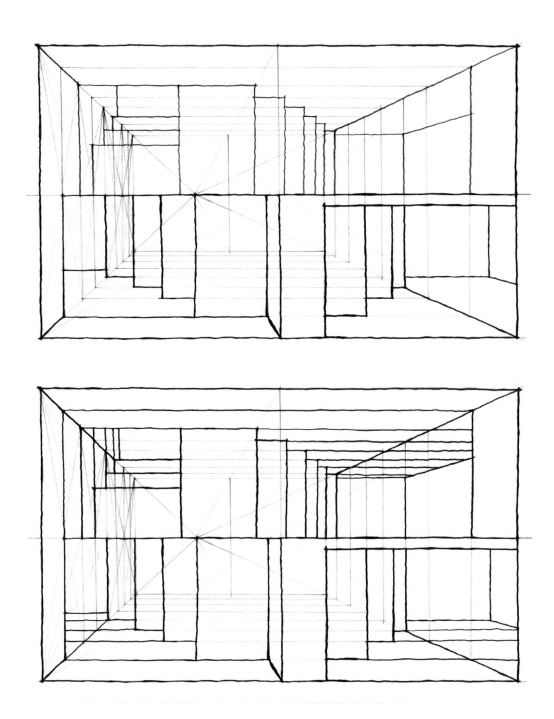

The wireframe of the objects sketched guided by the imaginary boxes.

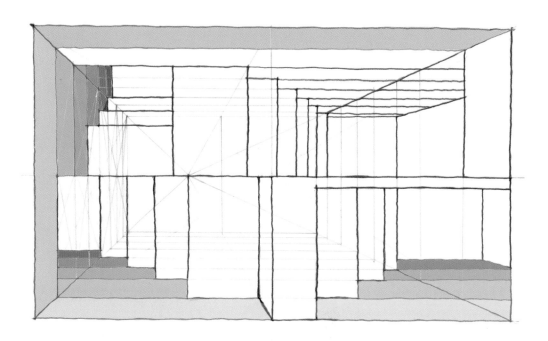

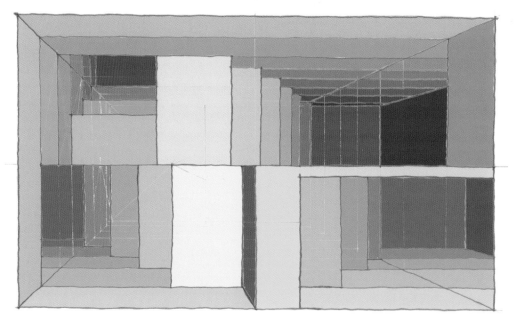

A simple colour rendering to show the formation of the objects surfaces in the composition.

4.1.25 CREATIVE COMPOSITION 25

Sketching spiral stairs is a complex process. However, this becomes easier when one employs the imaginary box as guidance. Observe each step of the process given here. The risers and treads of the spiral are sketched by referring to the segments in the imaginary box. An artist should be able to understand how to create segments in a box, because they have many uses as shown in these examples.

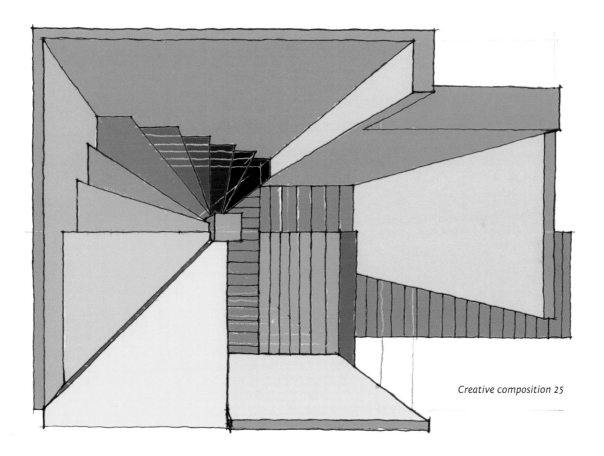

Creative composition 25

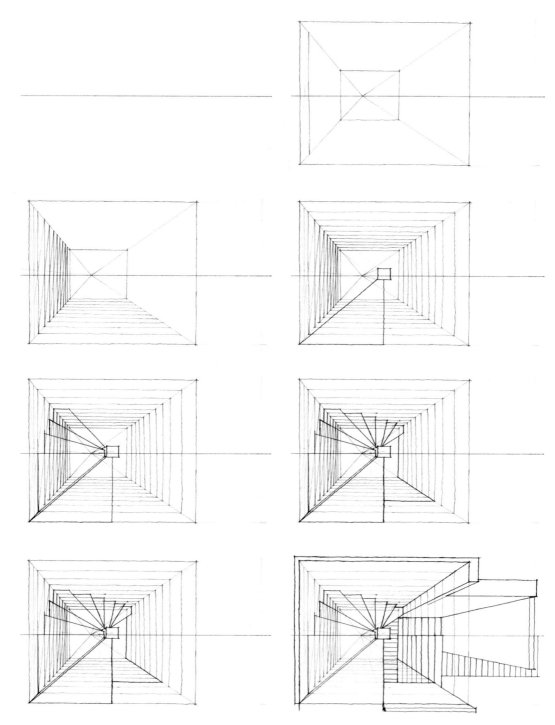

The step by step process of sketching spiral steps composition.

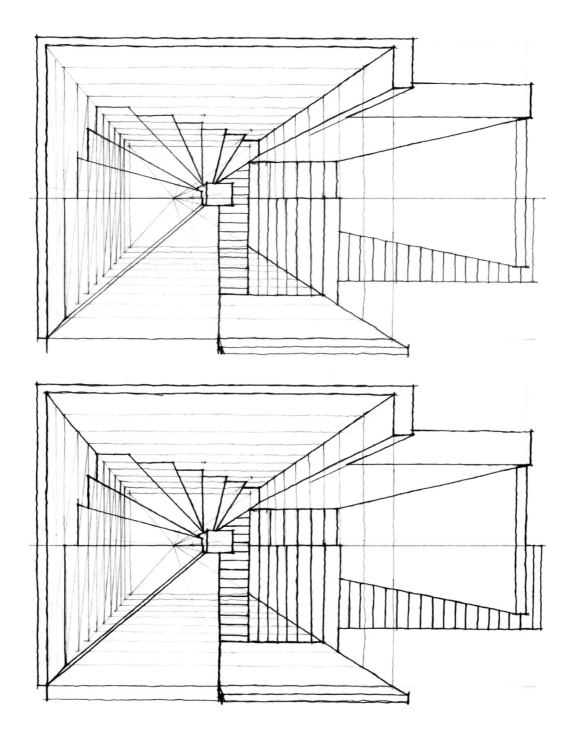

The wireframe of the objects sketched guided by the imaginary boxes.

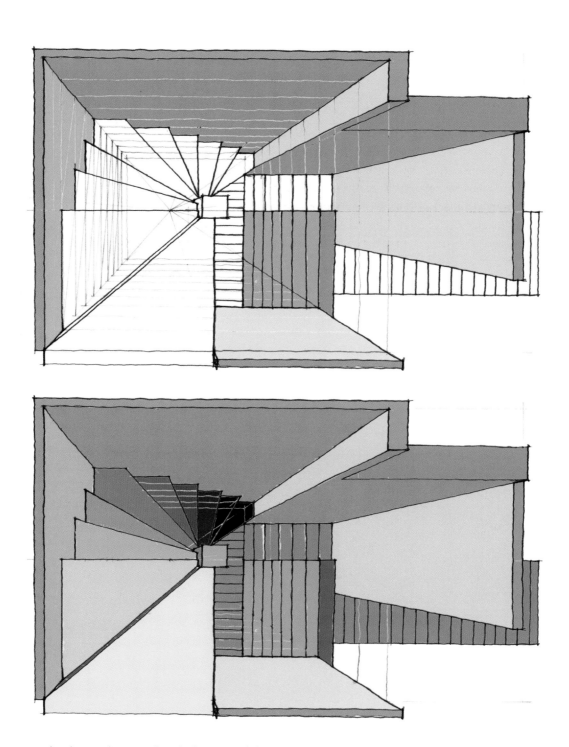

A simple colour rendering to show the formation of the objects surfaces in the composition.

4.1.26 CREATIVE COMPOSITION 26

This is a unique process of combining a stairway and a ramp in a composition that you can observe and practice. The elements of the composition are created based on an imaginary box. The box is divided into a few sections. Each section represents the elements of the stairway and the ramp. Both elements have their distinct characteristics that need to be carefully sketched to obtain a fine, balanced composition. The risers and treads are the details for the stairway while the curved lines constitute the ramp.

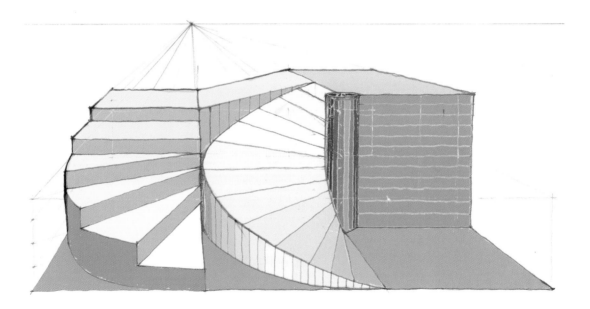

Creative composition 26

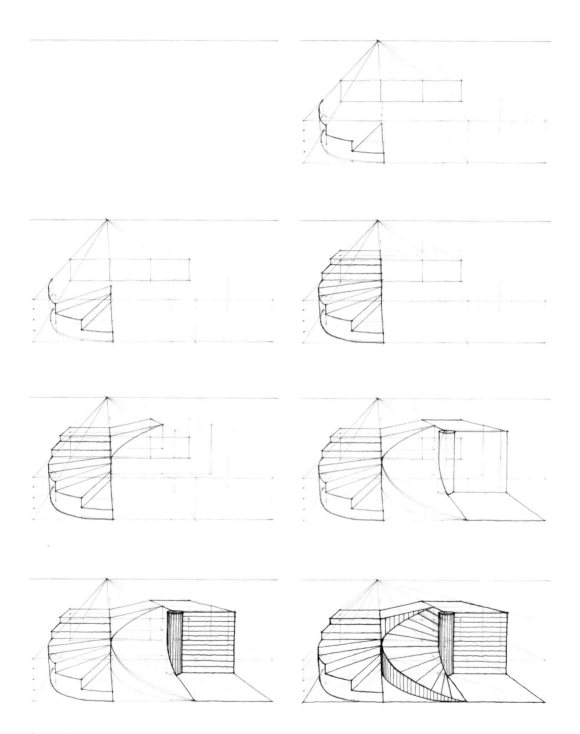

The step by step process of sketching the curved steps and ramp composition.

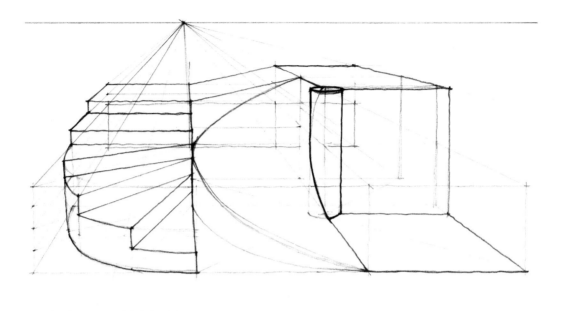

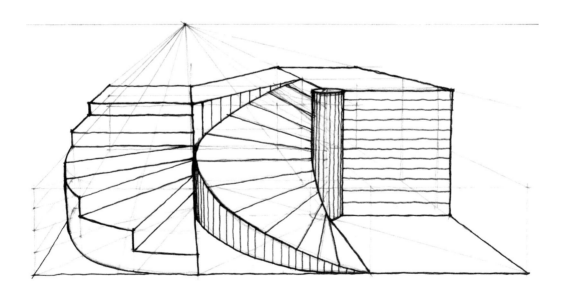

The wireframe of the objects sketched guided by the imaginary boxes.

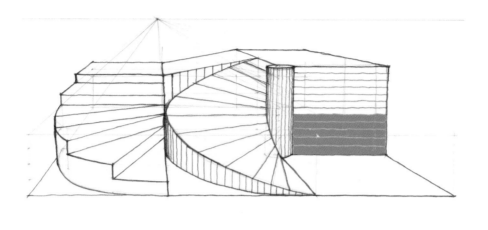

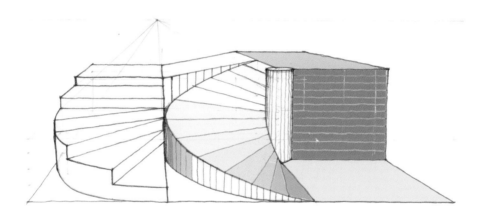

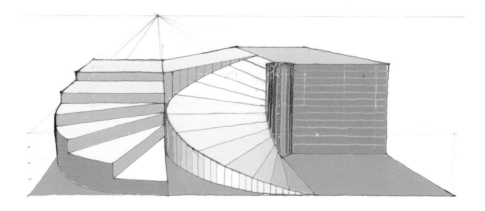

A simple colour rendering to show the formation of the objects surfaces in the composition.

4.1.27 CREATIVE COMPOSITION 27

Here, we explore a spiral stairway concept. Creating this composition begins by dividing the depth of the imaginary box into a few segments. Each step of the process is shown here. Then, you continue to sketch the forms into their spiral positions by using the imaginary box, horizon line, and vanishing point as guides.

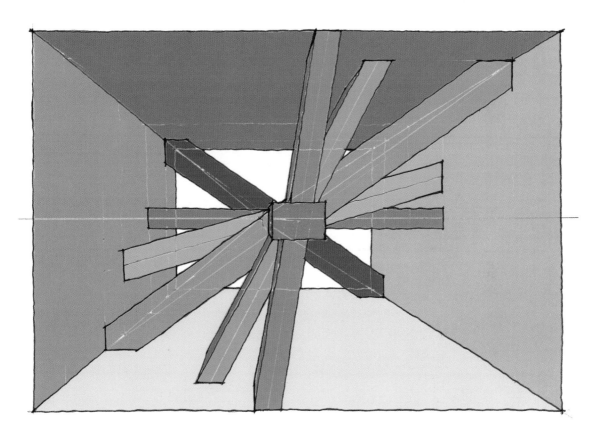

Creative composition 27

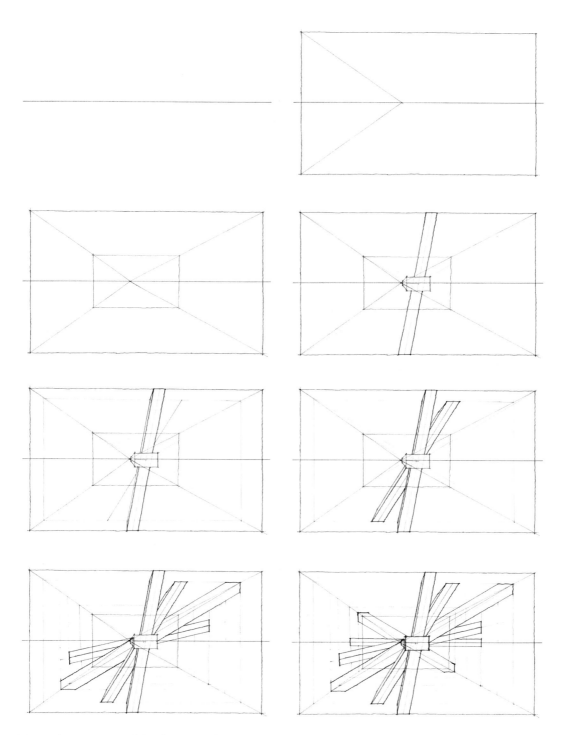

The step by step process of sketching a spiral composition.

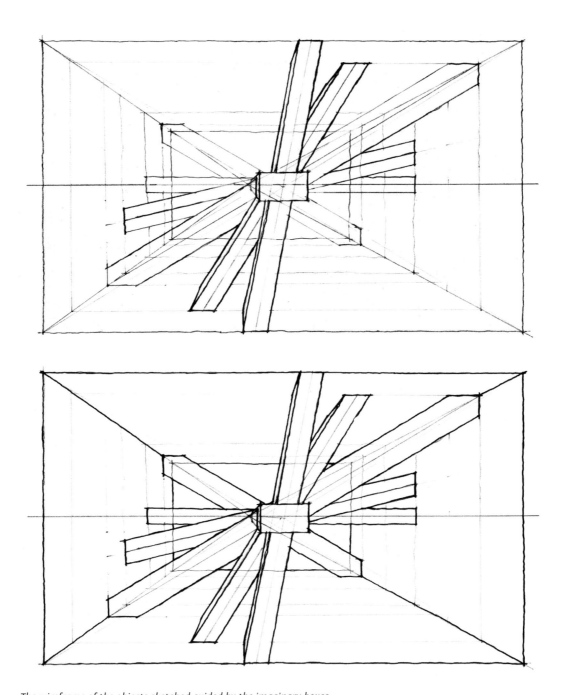

The wireframe of the objects sketched guided by the imaginary boxes.

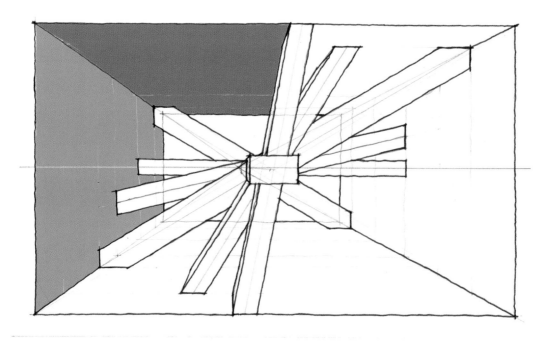

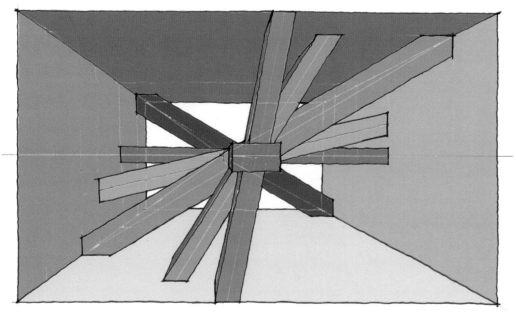

A simple colour rendering to show the formation of the objects surfaces in the composition.

4.1.28 CREATIVE COMPOSITION 28

The imaginary box provides an artist with many good avenues to explore more interesting creative compositions. Observe this composition. The creative forms are sketched using an imaginary box as a guide. The forms are a combination of horizontal and vertical zigzag lines. It is important to remember that the overall process of sketching the composition should refer to the three elements in a one point perspective setting: the imaginary box, the horizon line, and the vanishing point.

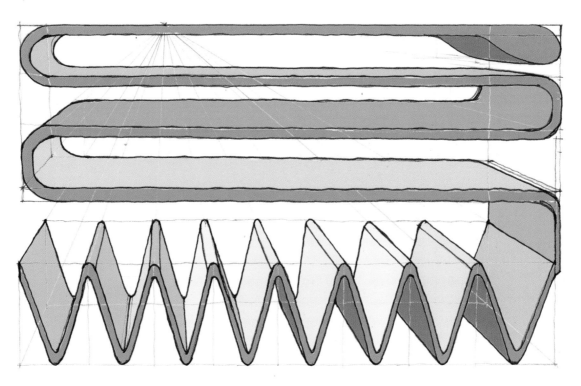

Creative composition 28

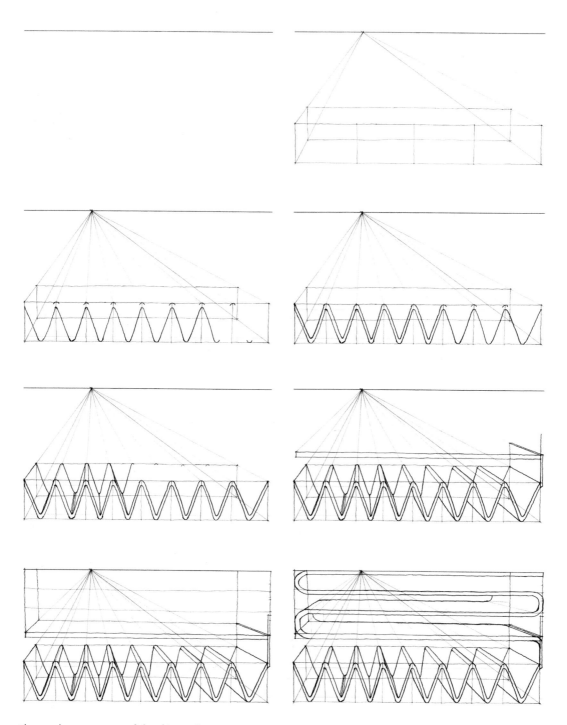

The step by step process of sketching a zigzag composition.

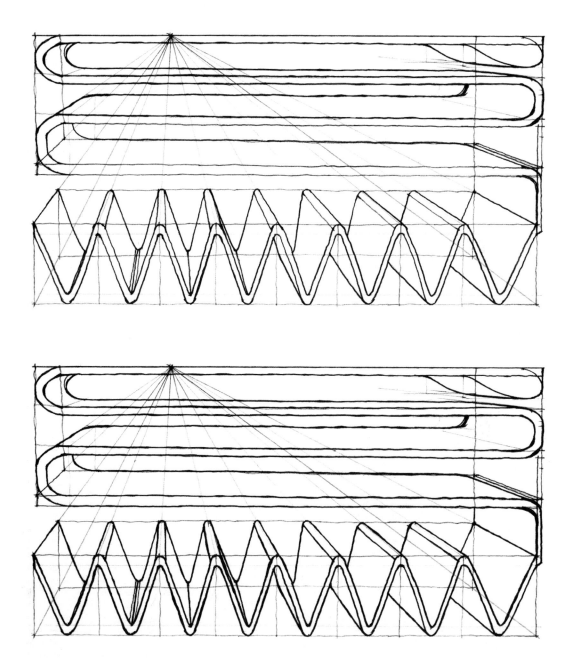

The wireframe of the objects sketched guided by the imaginary boxes.

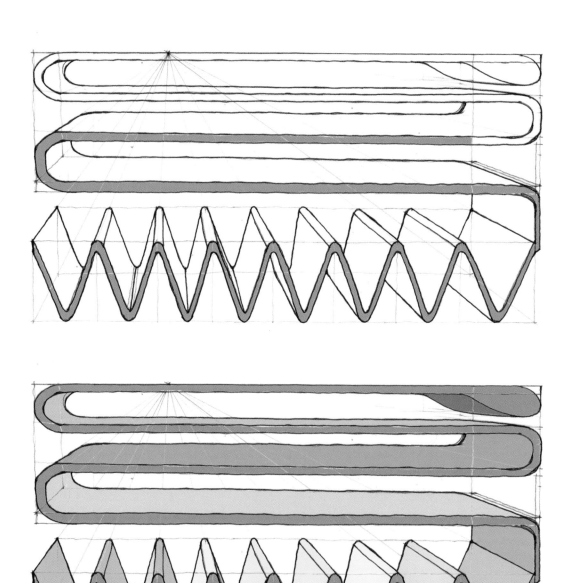

A simple colour rendering to show the formation of the objects surfaces in the composition.

4.1.29 CREATIVE COMPOSITION 29

The exploration of forms is a good exercise that allows you to acquire the skill of sketching in a one point perspective setting. Many types of forms can be created using the imaginary box as a guide. Observe the creative composition given. It is a combination of many forms in different positions and locations. Maneuvering the liens is a challenge for an artist because it involves the understanding of depth, width and height in a one point perspective setting.

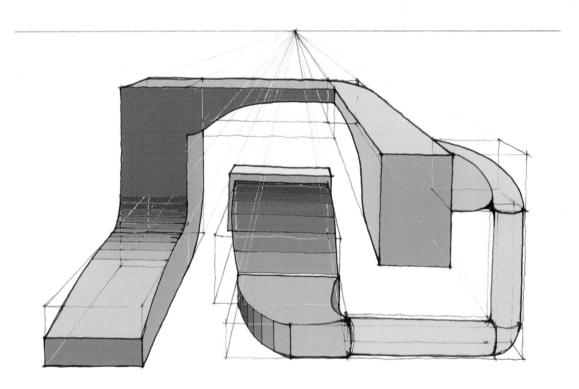

Creative composition 29

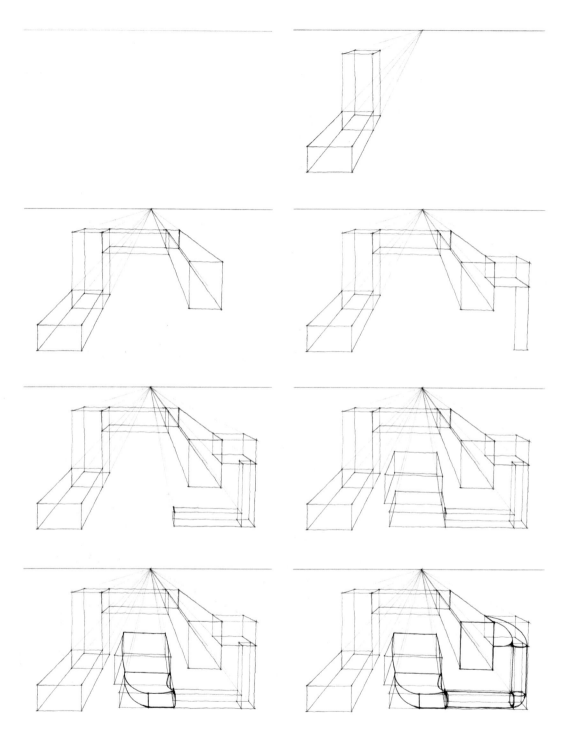

The step by step process of sketching a complex composition.

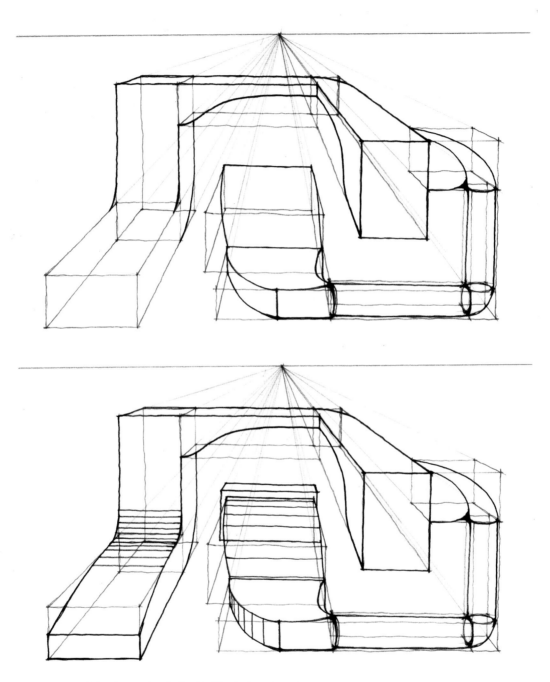

The wireframe of the objects sketched guided by the imaginary boxes.

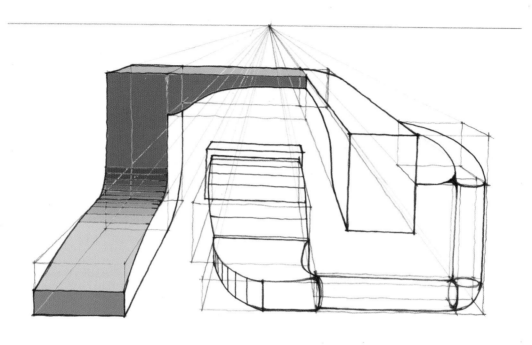

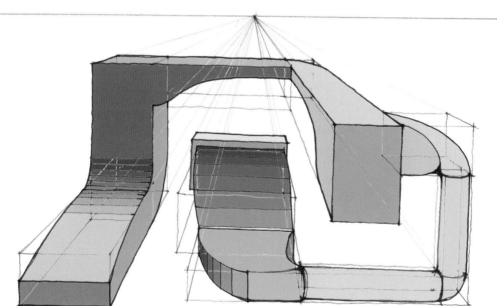

A simple colour rendering to show the formation of the objects surfaces in the composition.

4.1.30 CREATIVE COMPOSITION 30

Sketching a spiral form is challenging. Observe this composition and look carefully at the process of forming the spira. It begins with setting up the imaginary box. Then, a few segments are sketched in the imaginary box. The process continues by applying lines one by one to form the composition. Each line drawn should refer to the imaginary box.

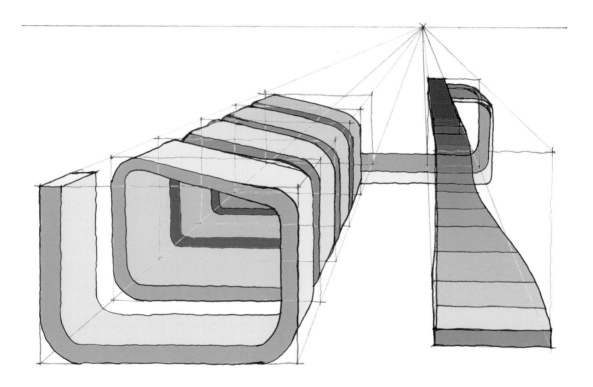

Creative composition 30

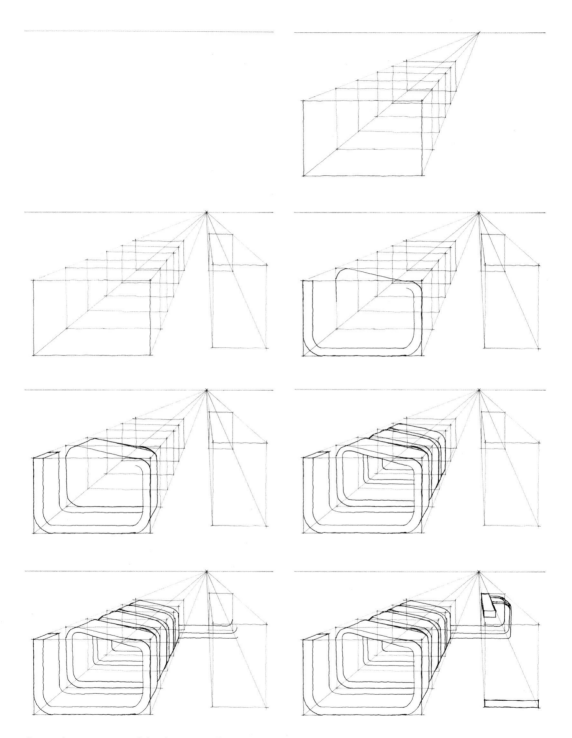

The step by step process of sketching a spiral composition.

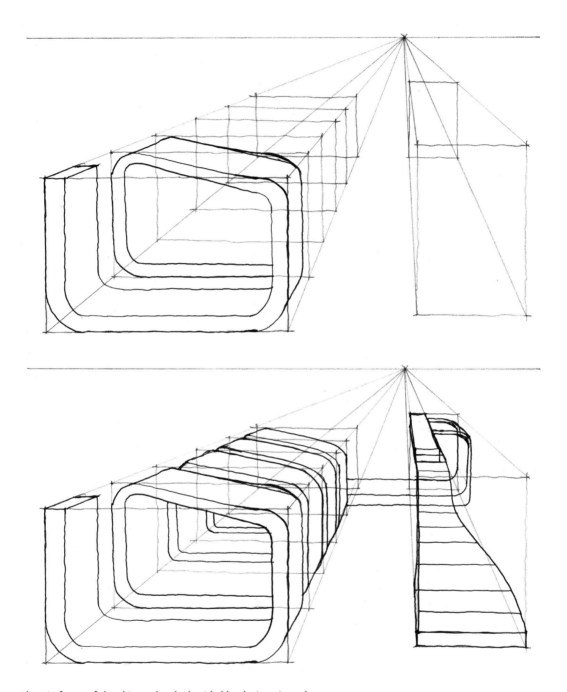

The wireframe of the objects sketched guided by the imaginary boxes.

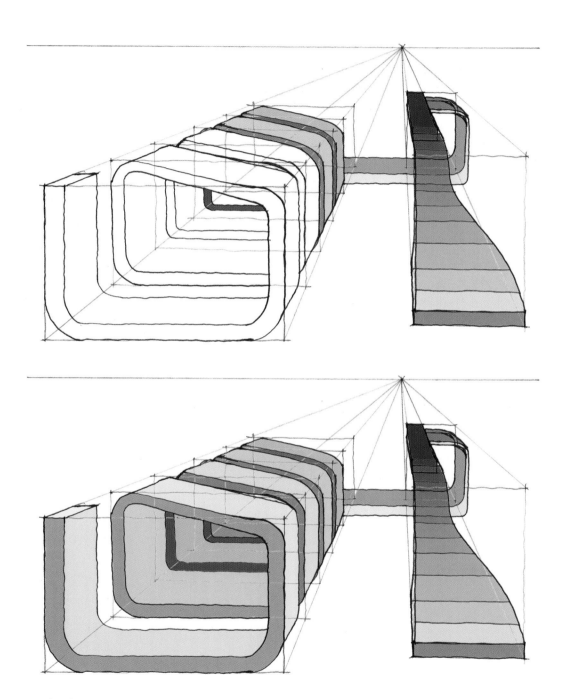

A simple colour rendering to show the formation of the objects surfaces in the composition.

4.1.31 CREATIVE COMPOSITION 31

Curved and triangular forms are interesting objects to sketch. Many of such forms can be created using an imaginary box as a guide. Observe the composition given. Three forms are created with the help of an imaginary box. Look carefully at how the lines are projected from one corner to another to compose the forms.

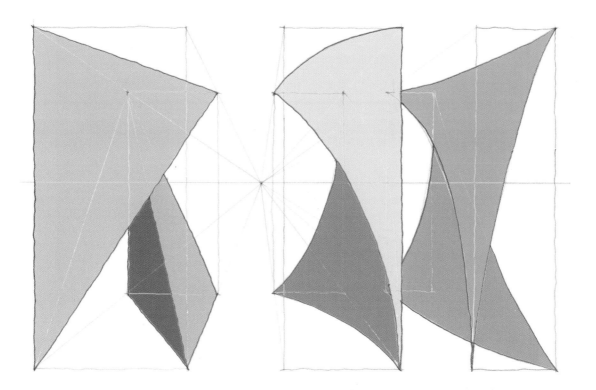

Creative composition 31

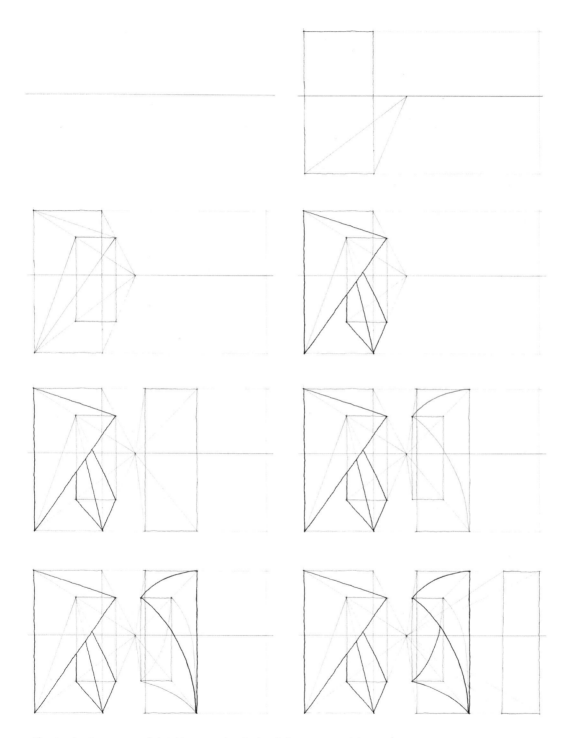

The step by step process of sketching curved and triangle forms composition.

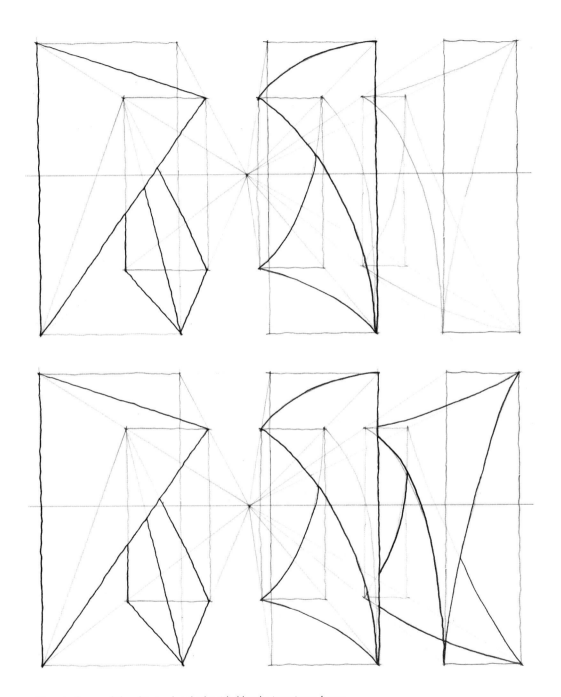

The wireframe of the objects sketched guided by the imaginary boxes.

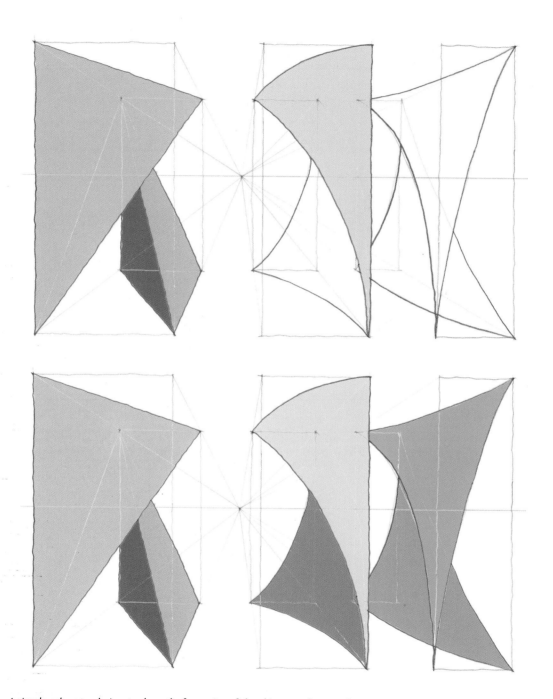

A simple colour rendering to show the formation of the objects surfaces in the composition.

4.1.32 CREATIVE COMPOSITION 32

Many types of curved forms can be sketched using imaginary boxes as guides. Observe the curved forms given. These forms are sketched using curved lines with different curvatures. A factor that influences the curvature of a line is the imaginary box. The width, height and depth of the imaginary box govern the formation of the curved forms.

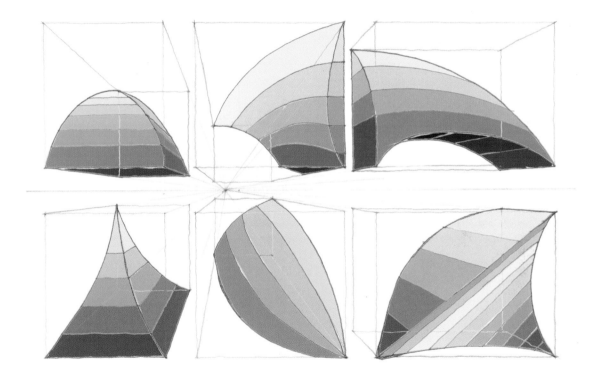

Creative composition 32

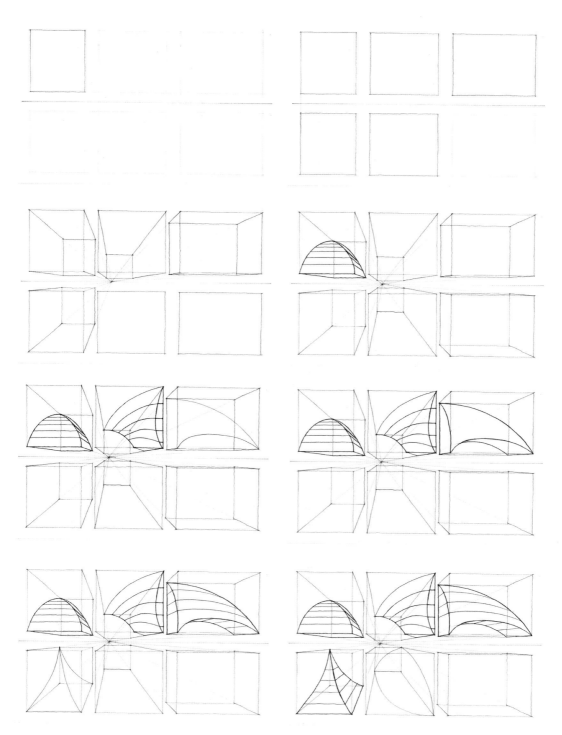

The step by step process of sketching the curved forms composition.

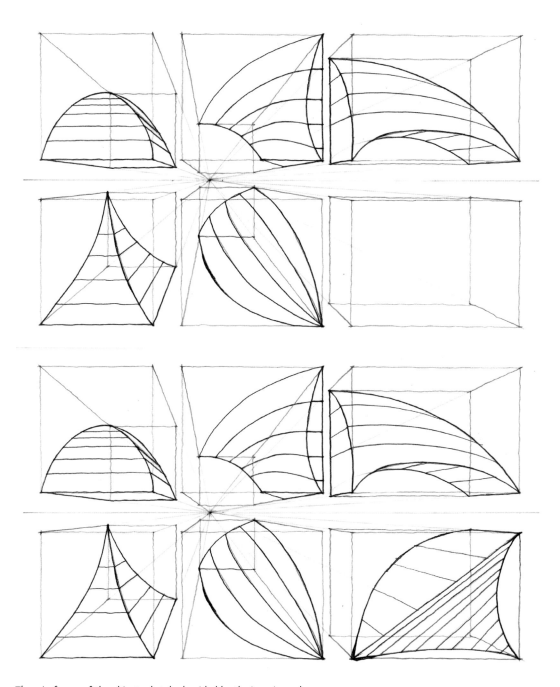

The wireframe of the objects sketched guided by the imaginary boxes.

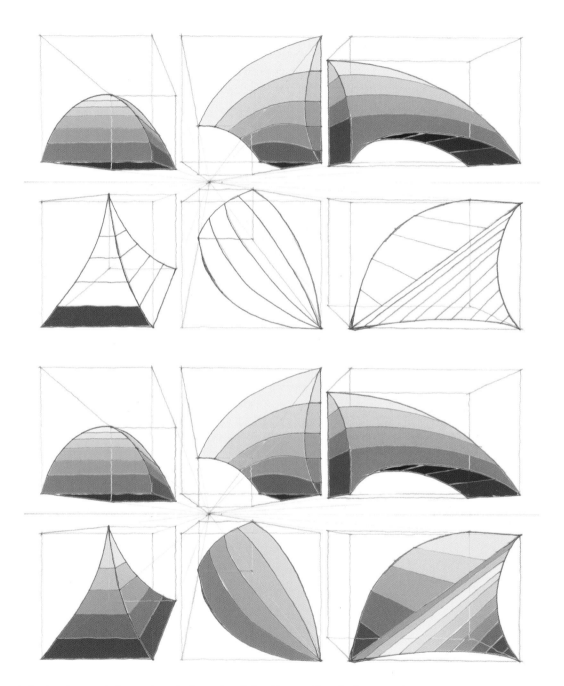

A simple colour rendering to show the formation of the objects surfaces in the composition.

4.1.33 CREATIVE COMPOSITION 33

Lines are one of the important elements in sketching a quality creative composition. Many types of lines are available for an artist to explore and employ in a composition. Observe the composition given and identify the types of lines used. While some straight lines are used, most of the lines are the curved with varying curvatures.

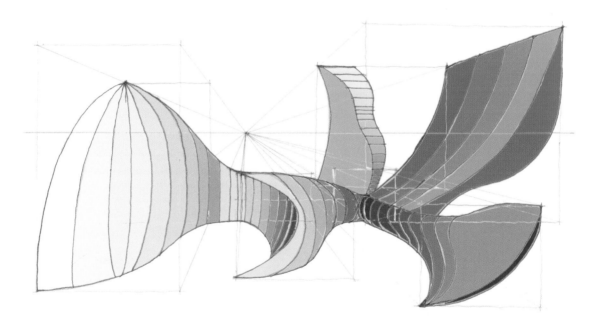

Creative composition 33

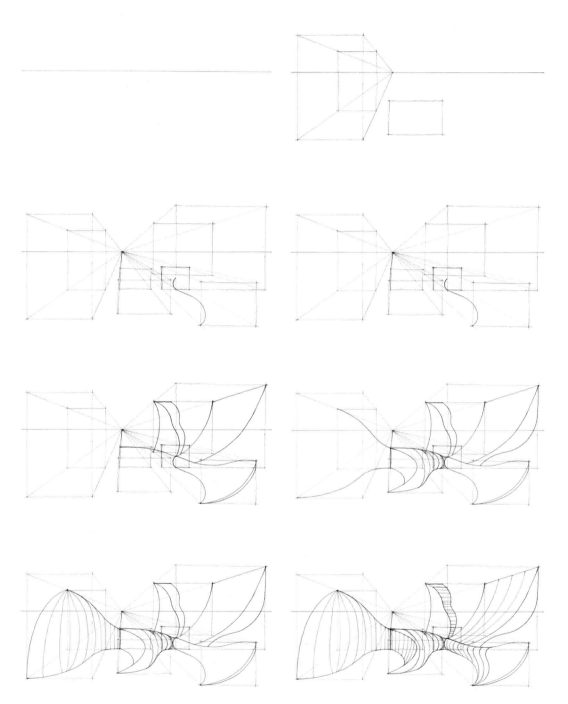

The step by step process of sketching curved objects composition

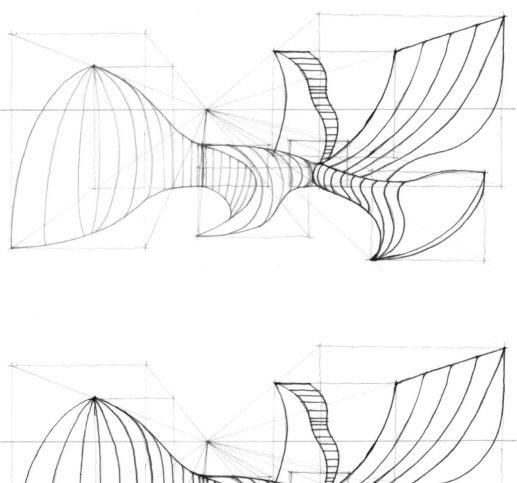

The wireframe of the objects sketched guided by the imaginary boxes.

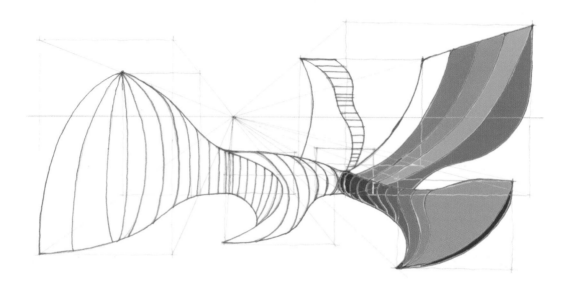

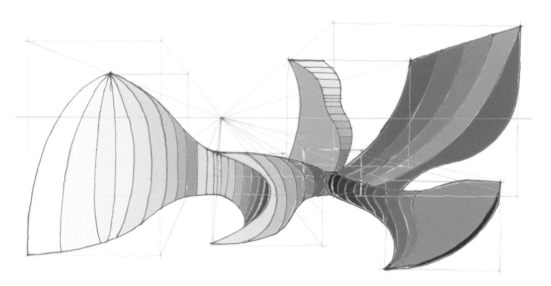

A simple colour rendering to show the formation of the objects surfaces in the composition.

REFERENCES

Ruzaimi, M.R., *Perspective Creative 02, Two Point Perspective*, Singapore, 2012.

Ruzaimi, M.R., *Perspective Creative 01, One Point Perspective*, Singapore, 2011.

Ruzaimi,M.R.,& Ezihaslinda,N., *Sketching Masterclass*, Page One, Singopore,2010.

Ruzaimi,M.R.,& Ezihaslinda,N. *Drawing Masterclass*, Page One, Singapore, 2010.

Ruzaimi, M.R., *The Sacred Garden, Exploration of Garden Design Through Mind Composition*, Pelanduk Publication, Kuala Lumpur, 2003.

Ruzaimi, M.R., *How to draw using a box*, Blurb Inc.,2008

Robert W.G, *Perspective From Basic to Creative*, Thames & Hudson, 2006.

Francis D.K, Ching, *A Visual Dictionary of Architecture*, John Wiley & Sons. Inc, 1997.

Francis D.K, Ching, & Corky B., *Interior Design Illustrated*, John Wiley & Sons. Inc, 2005.

Francis D.K, Ching, & Steven P.J., *Design Drawing*, John Wiley & Sons. Inc, 1998.

Mike W. Lin, *Drawing and Designing With Confidence, A Step by Step Guide*, John Wiley & Sons. Inc, 1993.

Angela Gair, *The Artist's Handbook, A Step by Step Guide to Drawing, Watercolor and Oil Painting*, Abbeydale Press,1998.

Kingsley K. Wu, *Freehand sketching in the architectural Environment* ,Van Nostrand Reinhold, 1990.

Paul Taggart ,*Art techniques from pencil to paint*, Sterling, 2003.

Paul Laseau, *Graphic thinking for architects and designers*, Van Nostrand Reinhold, 1989

David Sibbet, *Visual Meetings: How Graphics, Sticky Notes & idea Mapping can transform Group Productivity*, John Wiley and Sons.Inc., New Jersey, 2010.

Koos E & Roseline, S., *Sketching: Drawing techniques for product designers*, Page One, Singapore, 2008.

THE AUTHOR AND ILLUSTRATOR

Ruzaimi Mat Rani graduated with a Master of Landscape Architecture degree from the Edinburgh College of Art (ECA), Heriot-Watt University and Bachelor Degree of Architecture from University Technology Malaysia (UTM). His interest in sketching, drawing and painting started in the primary and secondary school, continuing to higher education levels. His artworks have been exhibited in Bakat Muda Sezaman and PNB Art Exhibition.

His most important artworks are:

2003 Collection of 500 pieces Edinburgh Old Town Sketches.

1999 Collection of 85 pieces of the Sacred Garden Collection.